Performance

Perfor

mance

Diana Taylor

Translated from Spanish by Abigail Levine

Adapted into English by Diana Taylor

Duke University Press
Durham and London
2016

Designed by Amy Ruth Buchanan
Cover design by Natalie F. Smith
Typeset in Chaparral Pro and Helvetica Neue

Library of Congress Cataloging-in-Publication Data
Taylor, Diana, [date] author.
[Performance. English]
Performance / Diana Taylor ; translated from
Spanish by Abigail Levine ; adapted into English by
Diana Taylor. pages cm
Includes bibliographical references and index.
ISBN 978-0-8223-5954-8 (hardcover : alk. paper)
ISBN 978-0-8223-5997-5 (pbk. : alk. paper)
ISBN 978-0-8223-7512-8 (e-book)
1. Performance art. 2. Performance art—Political
aspects. I. Title.
NX456.5.P38T3913 2015
700—dc23 2015019796

To **José Esteban Muñoz**, my friend and colleague

To the wonderful Hemisexuals at the Hemispheric Institute:

Marlène Ramírez-Cancio, Marcial Godoy-Anativia, Francis Pollitt, and Lisandra Ramos

And to the extraordinary **artists, scholars**, and **activists** who accompany us.

This is one more contribution to our ongoing discussions about the many ways of doing and knowing that animate us.

Contents

Acknowledgments

My deepest thanks to Abigail Levine for helping me throughout the process of translating and adapting this version of *Performance* for an English-language audience; to Ken Wissoker, my wonderful editor, for his faith in my work, to Marcial Godoy Anativia for his feedback, and to Richard Schechner, André Lepecki, Tavia Nyongo, Laura Levin, Julio Pantoja, Lorie Novak, Francis Pollitt, and Marlène Ramírez-Cancio for their suggestions and support.

Thanks to New York University's Humanities Initiative for supporting the translation of this book.

What I shall have
to say here is
neither difficult nor
contentious; the
only merit I should
like to claim is that
of being true, at
least in parts.

—J. L. Austin, *How to Do Things with Words*

Preface

When I die, I want my headstone to read "It seemed like a good idea at the time." Much of what I've done in life seems to fall into that category, including the first version of this book. It was 2009, during the Seventh International Encuentro (or ten-day conference/performance gathering) of the Hemispheric Institute, held that year in Bogotá, Colombia. Guido Indij, director of Asunto Impreso publishing house in Argentina, said to me: "Why don't we make a little glossy book on performance. It can be short—say, forty or so pages of your text and images from the Hemispheric Institute's archive?" It seemed like a good idea. While the Hemispheric Institute of Performance and Politics has fifty institutional members throughout the Americas, artists, scholars, and students still do not share a common vocabulary. The little book was very glossy, pocket-sized, with wonderful production value. It even won a design award. It came to 176 pages, and took me forever to write in dialogue with the images I wanted to use. Marlène Ramírez-Cancio and Marcial Godoy-Anativia helped me write, edit, and review the manuscript, and Zoe Lukov helped find and organize the images.

When Ken Wissoker of Duke University Press and I discussed publishing it in English, that too seemed like a good idea. But a

small, high-production-value book on performance in English is a very different thing. The costs of publishing in the United States made the format almost prohibitive. And I couldn't simply put out the same book for an audience that was well rehearsed in the topic of "performance." This, then, was not simply a translation project, although I thank Abigail Levine for rendering the original Spanish text into English. I then rewrote it. So the little book went from being an introduction to a field to being part introduction and part reflection on some of the uses of performance that interest me most—the power of performance to enable individuals and collectives to reimagine and restage the social rules, codes, and conventions that prove most oppressive and damaging. While I am constantly inspired by the artists, activists, and scholars I work with, the limitations are only my own.

I dedicate this book to José Esteban Muñoz, my friend and colleague in Performance Studies at New York University. When I showed him the little glossy book right off the press, he looked at it and turned it over in his hands. His face was as impassive as only he could make it, and he flipped through the pages and turned the book this way and that. "Yes," he said, "it has pages, words, a front cover, a back cover . . ." He flipped through it again: "Yes, it's a book." José *querido*, this book is for you.

1

Framing [Performance]

..

Since the 1960s, artists have used their bodies to challenge

regimes of power and social norms, placing the body **FRONT**

AND CENTER in artistic practice—no longer the object depict-

ed in paintings, or sculpture, or film, or photography but the

living flesh and breath of the act itself. For some, performance

refers to **PERFORMANCE ART** or **BODY ART** or **LIVE ART** or **AC-**

TION ART, terms that accentuate both the centrality of the liv-

ing artist in the act of doing and the aesthetic dimension, "art."

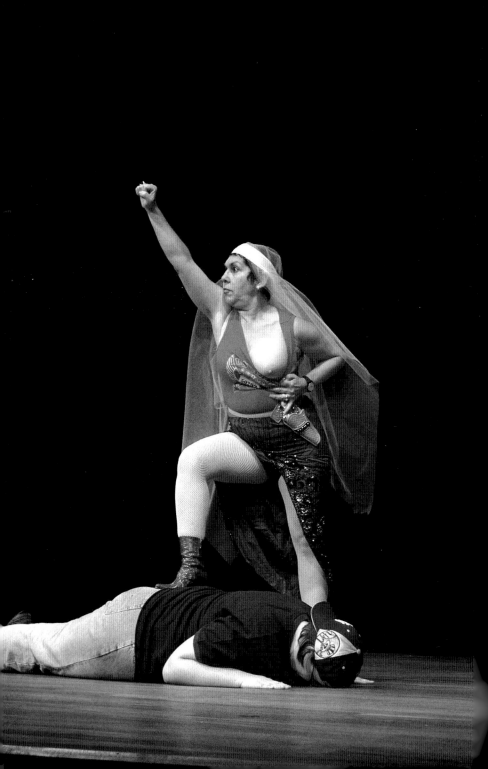

Carmelita Tropicana (Cuba/U.S.) recognizes the transformative potential of performance: "Performance is KUNST (art) that is fluid, messy, a hybrid; an art that liberates the performer and spectator with the cri de coeur of the French Revolution: liberté, égalité, homosexualité!"

Guillermo Gómez-Peña (Mexico/U.S.) inhabits performance: "For me performance art is a conceptual 'territory' with fluctuating weather and borders; a place where contradiction, ambiguity, and paradox are not only tolerated, but also encouraged. The borders of our 'performance country' are open to nomads, migrants, hybrids, and outcasts."[1]

Performance, for him, is not simply an act, or an action, but an existential condition. An ONTOLOGY. He says that the only difference between a performance artist and a madman is that a performance artist has an audience.[2]

1.1 Carmelita Tropicana in her performance *Come as Your Favorite Virgin Night*, presented at the 2003 Hemispheric Institute Encuentro in New York. Photo: Marlène Ramírez-Cancio

1.2 Guillermo Gomez-Peña in *Warrior for Gringstroika*. Photo courtesy of the Pocha Nostra Archive

"The word performance," says the woman in Diana Raznovich's cartoon, "is itself a performance!"

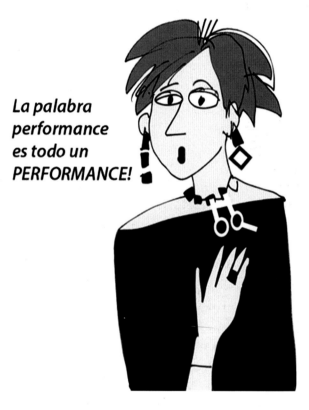

La palabra
performance
es todo un
PERFORMANCE!

1.3 Diana Taylor defining performance. Drawing by the humorist Diana Raznovich, 2010

PERFORMANCE is not always about art. It's a wide-ranging and difficult practice to define and holds many, at times conflicting, meanings and possibilities.

...

This book analyzes performance: what it *is*, but also, more important, what it *does*, what it allows us to see, to experience, and to theorize, and its complex relation to systems of power. The term is used in the theatre, in anthropology and the visual arts, in business, sports, politics, and science. Across these fields, it signals a wide range of social behaviors. Sometimes "art," sometimes political "actions," sometimes business management, sometimes military prowess, performance aims to create effects and affects. Performance moves between the AS IF and the IS, between pretend and new constructions of the "real."

...

Many of the ideas, photographs, and images in this book come from the fifteen years of collaboration that have taken place through the Hemispheric Institute of Performance and Politics (hemisphericinstitute.org). Artists, activists, and scholars from throughout the Americas meet regularly to share their practices and discuss how performance intervenes in society. Many have worked or continue to work in difficult circumstances—under military dictatorships or savage neoliberalism, in sexist, racist, and homophobic societies, some under conditions of poverty and social marginalization. One of the (many) challenges of working together across linguistic, political, economic, disciplinary, and aesthetic borders, however,

has been that the word "performance" does not exist in Spanish, Portuguese, or French. Negotiating the terms has been in itself an act of political and artistic translation.[3] As the word "performance" is increasingly accepted in Spanish, with its gendered pronouns, new issues arise about its "sex." Is it *el* performance or *la* performance? Bi? Trans? Some would say "Both," some would say "It depends" (in some cases the masculine is reserved for business and the feminine for artistic projects; sometimes it depends on the country). It's a fascinating debate, and some artists play with it. Jesusa Rodríguez (Mexico) says life should be as fluid as *performance* and "leave behind its gender prejudices—what's important is that spectators confront their own capacity for transformation, male, female, bird, witch, shoe, or whatever." While I do not take up the specific language-based issues in this book, many of the examples and insights I offer come from this Americas-wide network. The concepts and practices, however, far exceed these geographical contours.

The word "performance" in this broader transnational, transdisciplinary, multilingual context has a wide range of meanings. Elin Diamond defines performance in the broadest sense: a doing, something done.[4]

This **DOING/DONE** lens allows us to understand performance across temporalities—present and past.

DOING captures the *now* of performance, always and only a living practice in the moment of its activation.

In this sense, performance can be understood as *process*—as enactment, exertion, intervention, and expenditure.

William Pope.L, a New York–based artist, slowly crawls through city streets. "I am a fisherman of social absurdity, if you will. . . . I am more provocateur than activist. My focus is to politicize disenfranchisement, to make it neut, to reinvent what's beneath us, to remind us where we all come from."[5]

1.4 William Pope.L, *The Great White Way, 22 miles, 9 years, 1 street* (2001–ongoing), New York. Photo: Lydia Grey, courtesy of the artist

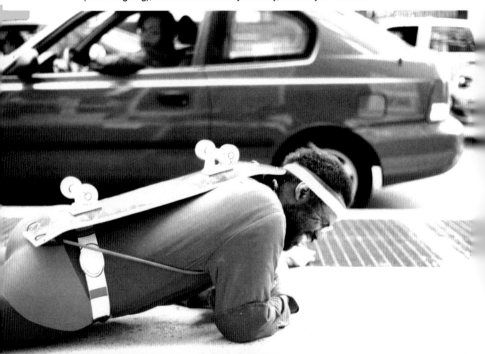

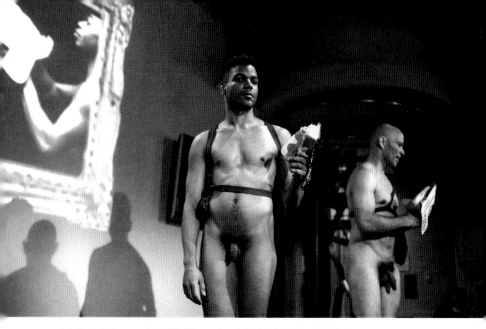

1.5 Revisited excerpt of *This Pleasant and Grateful Asylum* (2013) at
Performing the Archive, Hemispheric Institute of Performance and Politics,
NYU. First performed in collaboration with Charles Rice-González at the Point
Community Development Center, Bronx, NY (1999). Pictured (from left to right):
Video documentation of 1999 performance, Saúl Ulerio, and Arthur Aviles.
Photo: Laura Bluher

It is **ALSO** a thing **DONE**, an *object* or *product* or accomplish-
ment. In this sense, performance might be experienced or
evaluated at some different time. It might be collected by mu-
seums, or preserved in archives. Artists, too, may chose to per-
form in front of an archival image or video of their work to
emphasize changes and continuity between then and now.

The tension between the **DOING** and **DONE**—present and
past—is very productive. Performance has often been con-

sidered ephemeral, meaning "lasting only one day." Theorists such as Peggy Phelan have posited that performance "disappears" even as it comes into being, that it resists the "laws of the reproductive economy." It cannot be saved, she argues, or recorded or documented. When that happens, she maintains, it ceases to be performance and becomes something else.[6]

This, of course is true if we think about performance as only a discrete, singular act. But, we shall see, performance also works across time in intriguing and powerful ways. Instead of the once, the act that bursts on the scene only to vanish, we can also think of performance as an ongoing repertoire of gestures and behaviors that get reenacted or reactivated again and again, often without us being aware of them. If we learn and communicate through performed, embodied practice, it's because the acts repeat themselves. We recognize a dance as a dance, even when the moves and rhythms change. In this sense, then, performance is about past, present, and future.

..

On the first day the 2013 Hemispheric Institute Encuentro in São Paulo, Abigail Levine (U.S.) and two other dancers performed *Slow Falls* at entrance to the main theatre, leaving a record of their movements in tape on the building's exterior. The performance lasted two hours, but for anyone walking by the following days, the lines that remained invoked the presence of the dancers' bodies. Performances may take place, but do they entirely disappear, or do their effects endure? Large or small, visible or invisible, performances create change.

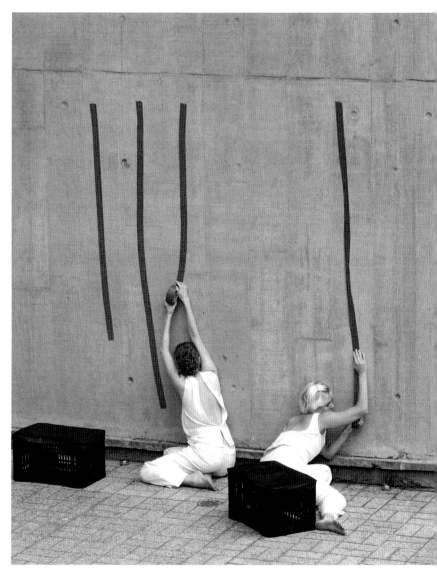

1.6 (*continued overleaf*) Abigail Levine, *Slow Falls*. Hemispheric Institute Encuentro, São Paulo, 2013. Photo: Francis Pollitt

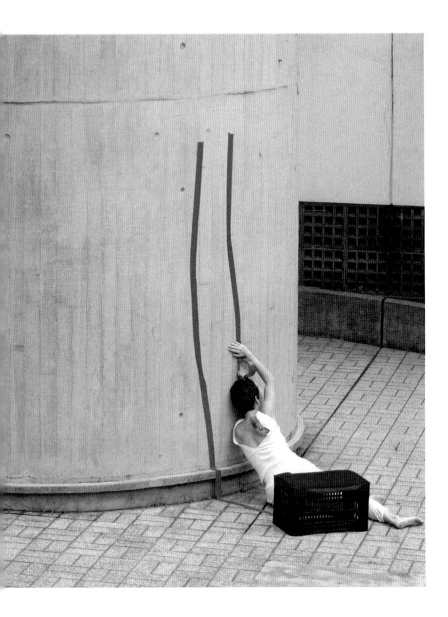

Doing, done, redoing

Doing is fundamental for human beings who learn through imitation, repetition, and internalizing the actions of others. This central theory—that people absorb behaviors by doing, rehearsing, and performing them—is older than the Aristotelian theory of mimesis (imitation, acting) and as contemporary as theories of mirror neurons that suggest that mirroring, empathy, and intersubjectivity are fundamental for human survival.[7]

Anna Deavere Smith (U.S.) often quotes her grandfather as remarking: "If you say a word often enough, it becomes you."[8] The reenacted becomes "real."

Although repetition and rehearsal is essential for human functioning, Maris Bustamante (one of Mexico's foremost performance artists) alerts us to the conservative potential of mimesis:

"We human beings are born clinging to each other and fundamentally programmed to reproduce what we are taught. Submitted to this programming, in this sense, we are victims of what others have made of us. Or to put it another way, we are not ourselves, we are . . . them."[9]

1.7 Maris Bustamente, *Instrumento de Trabajo*. Critique of Freud's theory of penis envy. Three hundred sweaty masks to be used by event assistants. Performance with No Grupo at the event *Caliente! Caliente!* Museo de Arte Moderno, Escuela de San Carlos Xochimilco and Escuela de Artes Universidad, Xalapa, Veracruz. Photo: Rubén Valencia

Performance, however, is not limited to mimetic repetition. It also includes the possibility of change, critique, and creativity within frameworks of repetition. Diverse forms such as performance art, dance, and theatre, as well as sociopolitical and cultural practices such as sports, ritual, political protest, military parades, and funerals, all have reiterative elements that are reactualized in every new instantiation.

These practices usually have their own structures, conventions, and styles that clearly bracket and separate them from other social practices of daily life.

[performance]

1.8 Giuseppe Campuzano in his performance *Cortapelo*, Arequipa, part of the project Museo Travesti del Perú. Photo: Miguel Coaquira, 2006

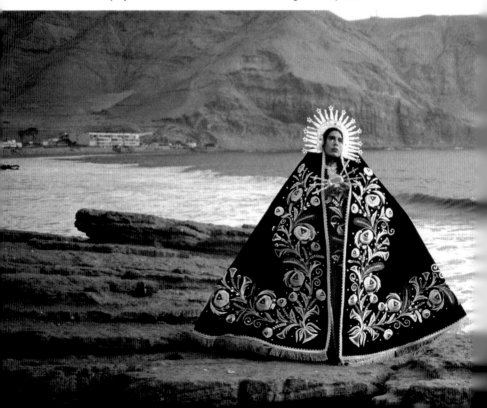

Each performance takes place in a designated space and time. A soccer game is a demarcated act (with a start and end time, a defined space, with rules, and a referee to enforce them). A political protest, too, has a beginning and end, and distinguishes itself from other cultural practices. In other words, performance implies a set of meanings and conventions. A protest is not just any walk down a public street.

Placing an event/image outside of its familiar context or frame can be, in itself, an act of intervention.

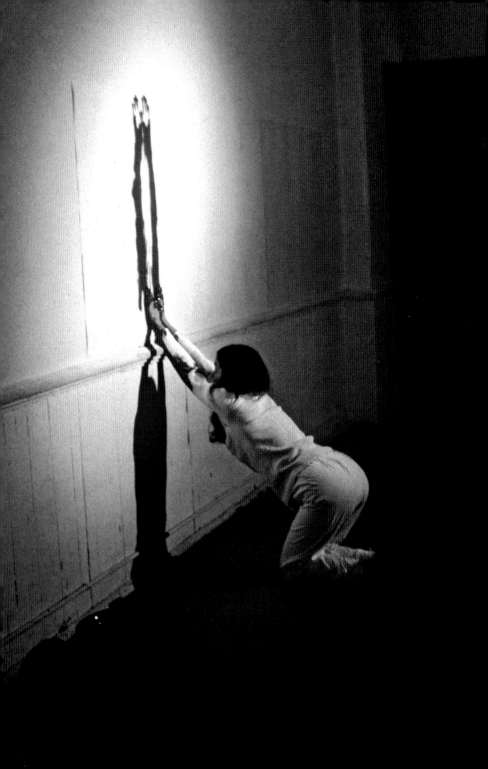

A performance implies an audience or participants, even if that audience is a camera. Ana Mendieta's (Cuba/U.S.) work, for example, was not always staged directly for spectators. People can experience it only through film or photographs.

Other kinds of performances such as ritual might restrict participation to those initiated in certain practices. Participating in the ritual might help cement membership in the group, or further reinforce social subcategorizations, exclusions, and stereotypes—women belong over here, men there, some groups nowhere, and so on. DOING becomes a form of BELONGING in a very specific way.

A public act, on the other hand, can be seen by all those who happen to be present.

In all these scenarios, the (social) actors, initiates, and spectators follow the implicit rules of the event, governed as it is by conventions and norms. We all know how to behave at a play, a concert, a funeral, or a political protest. We've learned by doing. Social behaviors are rehearsed, repeated, and incorporated—everything from secret handshakes to putting on one's scarf in a holy place to taking off one's hat in the theatre. Participation in itself constitutes a social practice, the learning and sharing of codes, whether we're aware of it or not. Sometimes we do not even know we're watching a performance, as

1.9 Ana Mendieta featured at the Hemispheric Institute, New York.
Photo courtesy of Franklin Furnace Archive, Inc.

in the "invisible" theatre that Brazilian practitioner Augusto Boal writes about, which "consists of the presentation of a scene in an environment other than a theatre, before people who are not spectators."[10] A couple begins to argue in a subway car, and all of a sudden everyone in the car joins in.

Some performances pass by in a flash, leaving nothing (apparently) but a memory.

Bel Borba (Brazil) dashes around the Praça Roosevelt in São Paulo (2013) with water bottles, quickly drawing a massive water painting. Astronauts float in space, attached by an umbilical cord. Heads, faces, arms, bodies, all sorts of figures magically come into focus. The entire painting can be seen in its entirety for about half an hour before it evaporates.

What is the work of performance?

The vanishing image? Or Borba's rapid movements (labor)? Or does the work constitute the interruption into the quotidian? An invitation to interact with the environment? *Take a look,* his work shouts. *This is possible!* Or all at the same time? Borba's interventions in the urban are not about changing it as much as showing that change is possible.

In 2013 María José Contreras (Chile) sent out a call via Facebook asking 1,210 ordinary citizens to lie down, head to foot, along Santiago's main avenue on the eve of the fortieth anniversary of the coup d'état on September 11, 1973—one person

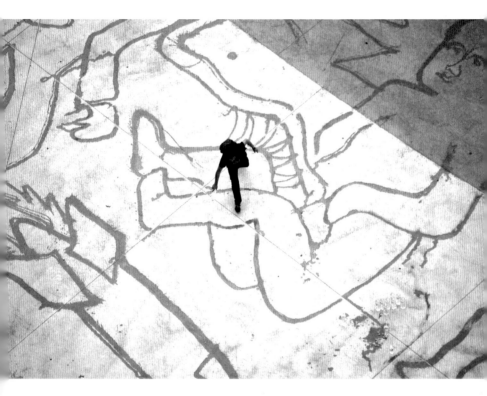

1.10 Bel Borba, *Diário: Bel Borba Aquí São Paulo*. Hemispheric Institute Encuentro, São Paulo, 2013. Courtesy of the artist

for each disappeared person killed during the dictatorship. The performance, **#quererNOver** (*#wantNOTtosee*), lasted exactly eleven minutes. While fleeting, it served as a powerful, collective testimonial that made visible the line or scar that historical events in Chile have left on the social body.

Other performances last for hours or days or even years.

Helene Vosters (Canada) fell one hundred times a day for an entire year, starting on Canada Day (July 1) of 2010—a meditation, she says, on the deaths in Afghanistan. The number of deaths kept creeping up, and she felt she couldn't feel, couldn't

1.11 Participants in performance of *#quererNOver* by María José Contreras, Santiago de Chile, September 10, 2014. Photo: Horacio Pérez

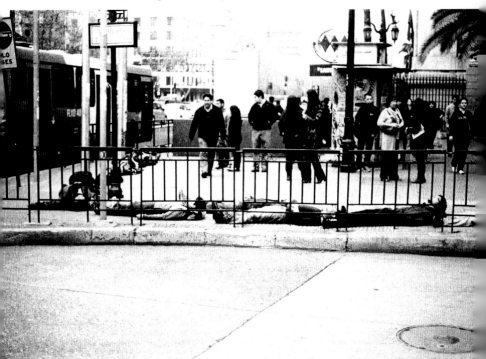

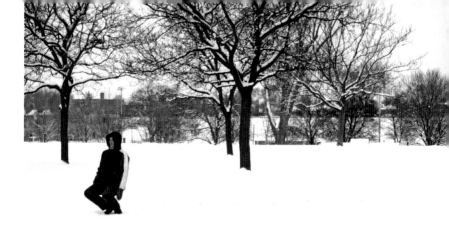

1.12 Helene Vosters falling in the snow in Christie Pits Park as part of Impact Afghanistan War. Photo: Shannon Scott

connect. The falling served as a sustained meditation. It made it impossible for her to go through a day without thinking about war. She had to organize her life around the falls: where she would be, safety, weather, clothing. A note to witnesses, written on a postcard of the Canadian flag, explains that her falls are her attempt to "reach beyond the numbness produced by abstract numbers, political debates, and media spectacularization." On July 1, 2011, she closed the performance with a group fall.

Durational performances, while reiterated or continuous, are not all of a piece. They evolve. They contain all sorts of interruptions, repetitions, episodes, and other short-lived acts

within a broad, ongoing structure. But they show something over time that cannot be known or captured at a glance.

Tehching Hsieh (Taiwanese-American) punched a time clock every hour on the hour for a year.

He and Linda Montano lived, tied to each other with an eight foot rope, for a year.

He lived on the streets of New York for a year.

He lived in solitary confinement in a cell for a year.

He lived without art for a year.

Each movement was taken out of context and ruthlessly stripped down to its most essential gesture until all the rhythms of daily life were turned on their head.

"Life is a life sentence," he says. "Every minute, every minute is different. You cannot go back. Every time is different but we do the same thing."[11]

The term "durational" can also help us understand certain forms of explicit ongoing political resistance. There are many examples. Hunger strikes are an excruciating example of "durational" performance of noncompliance by those who have lost control of everything except their bodies.[12] Every Thursday afternoon since the late 1970s, the Mothers of the Plaza de Mayo have marched counterclockwise around the obelisk of Argentina's central square, wearing white kerchiefs and

holding the photographs of their disappeared children. They have long struggled to make visible the dictatorship's crimes against humanity. They have left an indelible mark, not just on the plaza, but also in the awareness of the Argentinean people. The word "performance" does not suggest that their actions are not "real" or have no long-term consequences. It means that the mothers have used their bodies and their march ritualistically as a way of making political "disappearances" visible, nameable.

Performances operate as vital acts of transfer, transmitting social knowledge, memory, and a sense of identity through reiterated actions.

1.13 The white handkerchief of the Mothers of the Plaza de Mayo painted on the plaza. Photo: Lorie Novak, 2007

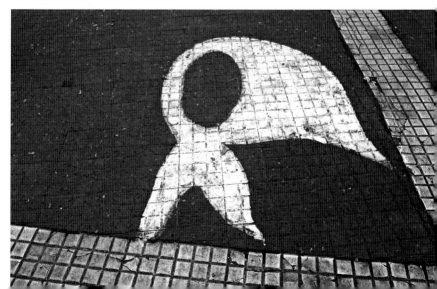

As Richard Schechner suggests, "performance means: never for the first time. It means: for the second to the nth time."

Performance is "twice-behaved behavior."[13]

Performance—as reiterated corporeal behaviors—functions within a system of codes and conventions in which behaviors are reiterated, re-acted, reinvented, or relived. Performance is a constant state of again-ness.

...

What does this do to the notion of the "original" as *foundational*, the *first* . . . as a cipher of creativity and as product . . . say, an original Picasso?

Or "authenticity"?

Is any act "original" and "authentic"?

Do these terms have meaning for performance outside the logic of the art market?

Recycling, rewording, and recontextualizing are the constants of most creative, and even scholarly, projects.

...

The startling, bold, new intervention takes place ONCE within a system or set of conventions that makes the work "legible" or comprehensible. Chris Burden (U.S.) had himself shot in the arm once (*Shoot*, 1971). Is this an "original" and "authentic"

work? Again, the frame helps (the space: F Space; the context: a friend shot him). It situates this as a performance, a conceptual art piece, not a random act of street violence. Yes, *Shoot* is a signature piece by Burden. The frame takes the act out of the realm of the doing and places it in the past. DONE. It now belongs to history and the art world. It may be subject to copyright. Yet I am not convinced that words such as "original" or "authentic" help us understand what the piece *is* or *does* within this system of embodied practice (performance art) guided by the logic of pressing the limits of the body. Were he, or someone else, to restage *Shoot*, would that not too, in the discourse of the art world, be "authentic" and a new "original"? (More about this in chapter 7.)

..

Schechner marks a distinction that is fundamental for understanding performance: the difference between something that IS performance (a dance, or a musical concert, or a theatrical production) versus something that can be studied or understood AS performance.[14] Almost anything can be analyzed AS performance: The nation-state is not a performance, but one may analyze the "staging" of the national, say in a State of the Union address. An election is not a performance, but it can certainly be understood as one!

But the slash in the IS/AS is slippery and changes with time and context. Are the following IS or AS?

Civil disobedience?

Resistance?

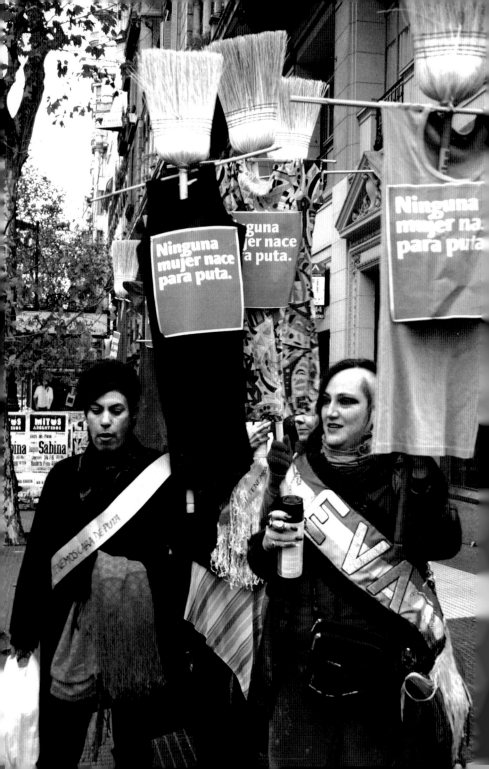

Citizenship?

Gender?

Race?

Ethnicity?

Sexual identity?

Or **BOTH**, at the same time?

...

It depends on how we **frame** the event. We might say a theatrical production **IS** a performance, and limit ourselves to what happens onstage. But we might broaden the frame to include the audience—how do they dress, how much do they pay per ticket, what kind of neighborhood is the theatre located in, who has access to the theatre and who doesn't? In 1990, Chicano artist Daniel J. Martínez staged *Ignore the Dents: A Micro Urban Opera* in the Million Dollar Theatre in downtown Los Angeles so that white, middle-class audiences who could afford the tickets had to line up in a Latino, working-class section of town. The performance took place offstage in their interactions with local residents as well as in the theatre. The frame allows us to examine this event in terms of both **IS/AS** performance. Each gives us a different sense of the politics, aesthetics, and meaning of "performance."

...

1.14 Mujeres Creando, *Ninguna mujer nace para puta*, urban intervention, part of the 2007 Hemispheric Institute Encuentro in Buenos Aires, Argentina. Photo: Marlène Ramírez-Cancio

The framing itself may be designed to provoke a certain reaction. Kent Monkman (Cree/Canada) inserts images of queer indigenous men into the majestic landscapes painted by colonial artists, emphasizing what colonialism has attempted to efface.

1.15 Kent Monkman, presentation at Hemispheric Institute Encuentro, Belo Horizonte, Brazil, 2005. Photo: Julio Pantoja

1.16 (*opposite*) Gonzalo Rabanal in *A Being Said, to Be a Name*. Hemispheric Institute Encuentro, São Paulo, 2013. Photo: Marlène Ramírez-Cancio

While embodied practices and attitudes are learned and enacted daily in the public realm, this does not mean that they are necessarily theatrical, put-on, "pretend," or conscious acts.

Simple everyday acts such as cooking, planting and harvesting crops, singing, drumming, and driving the kids to soccer practice, can transmit memory and a sense of belonging, identity, and cultural values from one generation to another and one culture to another. This is extremely important, especially for societies that do not transmit knowledge primarily through writing.

Learning to write, and the entry into print culture, as Gonzalo Rabanal (Chile) and his father show, can entail violent disciplinary embodied acts.

Beliefs and conventions are passed on through bodily practices, and so are all sorts of assumptions and presuppositions including how we understand *bodies*.

As Judith Butler explains, gender is not something we *have*, but something we *do*, a system of often invisibilized or normalized acts, product of a strict regime of socialization.[15] Pronouncing "It's a girl!" during an ultrasound or at the birth, thus, is not simply a statement; it's a discursive form of initiation into a entire way of acting and being. **PERFORMATIVITY**, she calls this, a concept we will return to later.

Sometimes we are not aware of the postures or routines that are associated with femininity or masculinity until a transvestite or an actor makes them apparent. "One isn't born, but rather becomes, a woman," Simone de Beauvoir told us in the 1940s. Gender is the product of discursive pronouncements and incorporated codes that are, in turn, acted out in the public sphere. Another way to recognize the conventions determining how gender gets performed is by examining how "women" look and act in different parts of the world or at different historical moments.

1.17 Peggy Shaw and Lois Weaver (Split Britches) in their performance *Retro Perspective / It's a small house and we've lived in it always* performed at the 2007 Encuentro in Buenos Aires. Photo: Julio Pantoja. http://hidvl.nyu.edu/video/000549155.html

According to Julieta Paredes, an Aymara queer, feminist, artist-activist, member of Mujeres Creando Comunidad (Women Creating Community) in Bolivia:

"Pachamama has granted us a performance: our phenotype."[16]

In Mexico, eighteenth-century caste paintings demonstrate clearly how this phenotype was created and activated in service of racial classification and segregation. Categories, imposed by colonial law, distinguished clearly between racial groups: mestizo (a person born to an indigenous woman and a European man, known as a *criollo*) and "coyote" (child of a mestizo woman and an indigenous man), among many others. Physical features and skin color were insistently marked, as if the differences between groups were a natural biological fact rather than a product of control, social stratification, naming, and prejudice. The further those of "mixed race" were distanced from the white man, the closer the nomenclature (coyote, wolf) approached the animal world. In addition, their clothing and customs were depicted as dark and dangerous, creating the very sense of racial difference that the paintings claimed only to depict.

Stereotypes reproduce and insist on certain structures of visibility.

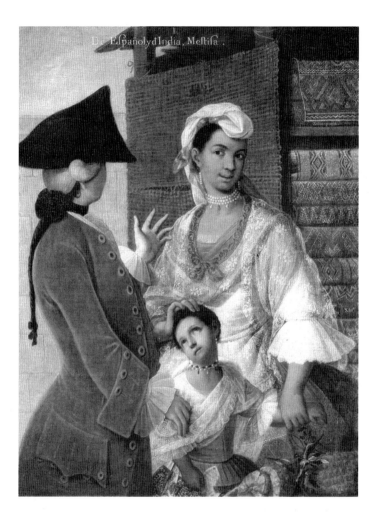

De Efpañol y d India, Meftifa .

1.18 "De Español y de India, Mestisa" from *Colección particular,*
México. In the upper right-hand corner is the signature "Mich.
Cabrera pinxit, Mexici, Anno 1763." Published in *Las castas*
mexicanas: Un género pictórico americano, ed. María Concepción
García Saíz (Milan: Olivetti, 1989)

Astrid Hadad (Mexico) has opted to work with quintessentially "Latin American" icons in order to reexamine them. Her work reproduces and plays with the stereotypical images that have become a model for sexual and ethnic identity of the Mexican woman: the Virgin of Guadalupe, Coatlicue (the Aztec mother of the gods), the butch who dresses in heels and spurs, the abused woman, the evil seductress. Hadad, with a refined irony, demonstrates the weight of iconographic accumulation and compulsive repetition. By producing ethnically overburdened images for public consumption, she calls attention to the delicate limits of cultural visibility in which the artist's body is seen as just one more repetition. Latin America, suggests Hadad, is only visible through its clichés, through the nature of its performative repeats. Her work plays with the discomfort that hides behind these images, showing how stereotypes of cultural, racial, sexual, and ethnic difference are produced, reproduced, and consumed.

Understanding these phenomena **is/as** performance suggests that performance functions not only as a condition or ontology, as Gómez-Peña proposes, but also as an **epistemology**, a form of knowing and understanding the world. In its character of corporeal practice and in relation to other cultural practices and discourses, **performance offers a way to transmit knowledge by means of the body**.

A simple example: what do we know about somebody by simply meeting them that we would not know by reading their CV, or hearing a recording, or seeing a photograph?

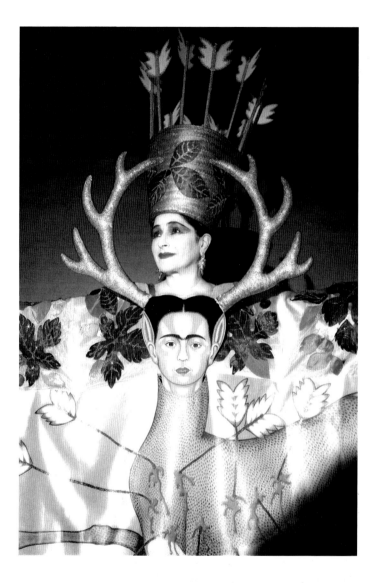

1.19 Astrid Hadad, *The Image of Frida and the Deer Dance*.
Photo: Antonio Yussif

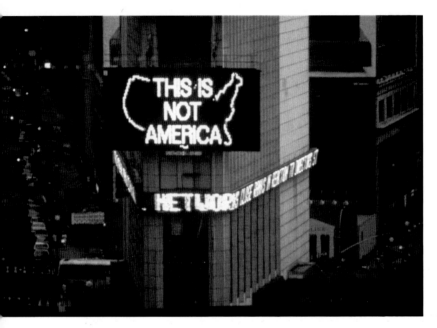

1.20 Alfredo Jaar, *A Logo for America*, 1987. Courtesy of the artist

Having insisted on performance as embodied practice, I need to make clear that performance practices sometimes do not take place on bodies or involve the bodies of the artists or activists. Again, it depends on how we understand performance—what it is and what it does. Alfredo Jaar's (Chile/U.S.) intervention in Times Square in New York City performs for us, the accidental audience.

There are, as we see, multiple definitions and uses for the word "performance."

Performance is a practice and an epistemology, a creative doing, a methodological lens, a way of transmitting memory and identity, and a way of understanding the world.

These diverse uses point to the complex layers of referentiality that seem contradictory but in fact at times support each other. Cultural anthropologist Victor Turner bases his understanding of the term on its French etymological root, *parfournir*, which means "to complete" or "to bring to completion." For Turner, as for other anthropologists writing during the 1960s and 1970s, performance revealed the deepest, most singular and genuine character of a culture. Guided by a belief in its universality and relative transparency, Turner proposed peoples and cultures could come to understand themselves through their performances.

"We will know one another better by entering one another's performances and learning their grammars and vocabularies."[17]

The key word here is *learning*.

Performances are neither universal nor transparent; their meanings change depending on the time and context and framing of their realization. Some may be decipherable to a small subgroup of initiates, and invisible or opaque to everyone else. The Franciscan friar Bernardino de Sahagún complained about not understanding the indigenous dances and songs he encountered in sixteenth-century Mesoamerica. He complained that "only they themselves understood them (for being things of the devil)."[18]

For others, performance means exactly the opposite: because it is a social construction, it indicates artificiality, simulation, or "staging," the antithesis of the "real" or "true." They refer to the linguistic roots of key terms as evidence: "art" is linguistically connected to "artifice"; "to make," *facere* shares an etymological root with *fetiche* (something made); "mimesis" belongs to the etymological family of "imitate," "mimic," "mimicry."

While in some cases, the emphasis on artificial aspects of performance as a socially constructed phenomenon reveals an antitheatrical prejudice, more complex readings recognize the constructed as a coparticipant of the "real."

Although a dance, a ritual, or a protest requires a frame that differentiates it from other social practices into which it is inserted, this does not mean that these performances are not "real" or "true." On the contrary, the idea that performance distills a truth that is "more true" than life, and that life itself is a stage, predates Aristotle, Shakespeare, Calderón de la Barca, and Artaud and continues into the present.

PERFORMANCE, as we will continue to explore throughout, means and does many—at times paradoxical—things. It's a **doing**, a **done**, and a **redoing**. It makes **visible**, and **invisible**; it **clarifies** and **obscures**; it's **ephemeral** and **lasting**; **put-on**, yet **truer** than life itself. Performances can normalize behaviors, or shock and challenge the role of the spectator very frontally and directly. Neither true nor false, neither good nor bad, liberating or repressive, performance is radically unstable, dependent totally on its framing, on the *by whom* and *for whom*, on the why where when it comes into being.

2

Performance Histories

..

Historically, the term "performance art" has been used to refer to a specific art form that emerged in the 1960s and 1970s. Some art historians, such as RoseLee Goldberg, consider performance's antecedents with the work of the Futurists, Dadaists, and Surrealists who focused more on the creative process than on the final artistic product. Although there are many isolated examples of earlier works that could be considered performance art, the movement of the '60s and '70s springs up as a widespread demand for the centrality of the living

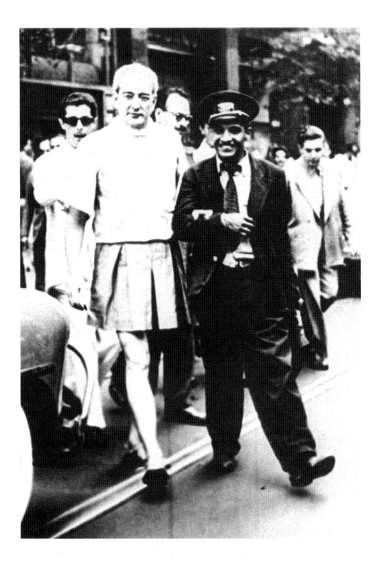

2.1 Flávio de Carvalho in his performance *Experiencia #3*
(1956), in which he walked through São Paulo in a suit he had
constructed for himself

body in a broad range of art practice. Fluxus demanded an end to "dead art" in the 1960s and pushed various art forms past their conventional limits. The historical trajectories of these early efforts are divergent, as are the arenas in which this work begins to circulate. For some, the concept of performance art comes out of the field of the visual arts. Carolee Schneeman, a pioneering performance artist in the United States in the early 1960s, considers herself a painter: "I had to get that nude off the canvas," she says.[1] She / her body became the media, the subject, and of course, the artist. For "action painters," such as Jackson Pollock (U.S.), painting on a canvas was also a performance. Others, like Allan Kaprow, coined their own terms (*Happenings*) for the new forms of artistic engagements that their work provoked, rupturing the wall between artists and audience members. Some early performance work by artists such as Laurie Anderson and Robert Wilson had ties to theatre according to Marvin Carlson.[2] Although these classifications, like much else in this field, have been contested, they serve to indicate that "performance" or "live" art has many antecedents, many interlocutors, many disciplinary ties, and many ways of breaking with them all.

Different countries and communities offer alternative genealogies of performance in the Americas. In Brazil, we could think of precursors such as Flávio de Carvalho, who made work in the 1930s, and visual artists Hélio Oiticica and Lygia Clark from the '50s and '60s.

Maris Bustamante and Mónica Mayer locate the origin of the practice of performance in Mexico with the arrival of surrealism and the development of non-object-based art.

In Canada, indigenous performance artist Rebecca Belmore (Anishinaabe) proposes that the story of performance art in Canada begins with the ethnographic display of indigenous persons. She tells of a Mi'kmaq man who was "taken to France where he was placed in a wilderness garden with a deer." She writes: "There, he was told he was to perform for an audience of nobility: he was expected to kill the deer with a bow and arrow, skin and dress the carcass, then cook and eat it. According to the Mi'kmaq, wrote the missionary, the man adhered to their instructions but took the liberty of expanding on their idea of his performance by 'easing himself before them all.' I took this to mean that he shat upon the ground. . . . I consider this Mi'kmaq man to be one of the first performance artists of the Americas to work internationally—hundreds of years ago."

As Rebecca Schneider reminds us, one must always refer to the *histories* of the emergence of performance art in plural so as not to fetishize notions of its origins, specific practices, locations, and authorship.[3] Performance practices change—be they artistic, political, or ritual—as much as the works they produce. While recognizing the power inherent in naming and claiming, it is important to recognize that what has been called "performance art" has roots in many artistic forms. However, it transcends these limits, bringing together many elements to create something unexpected.

Generally, performance art is radically concentrated in the body of the artist.

As Francisco Copello (Chile) writes:[4]

My art is my body.

The place of my desire—repressed, then liberated—becomes the body in all its most intimate manifestations, taken violently to the surface and subjected to collective verification. And of course, it is this inspection in front of everyone that makes it intolerable.

At the same time, performance artists were beginning to explore the limits of their own bodies. Chris Burden (U.S.) dragged his body through broken glass. Bob Flanagan (U.S.) pierced his penis, sewed up his lips and his scrotum, nailed his skin to wood, and performed many other acts that for him expressed invincibility in the face of his cystic fibrosis. Las Yeguas del Apocalypsis (Chile) danced the *cueca*, the national dance, on shards of glass, leaving bloody footprints over a map of Latin America to make visible the horror of torture and disappearance during the years of the Pinochet dictatorship.

These kinds of self-inflicted violent acts gave birth to a form that Kathy O'Dell has called **MASOCHISTIC PERFORMANCE**.[5]

Sometimes aggression and violence are directed at the audience. Ron Athey (U.S.), whose HIV-positive status was known, soaked paper towels with blood and hung them above a terrified audience. The blood was, in fact, that of a friend who was not HIV-positive and therefore posed no danger (real or imagined) to the public. In other performances, Athey cuts himself in acts known as **EXTREME PERFORMANCE**.

But in the '60s and '70s performance also played an important role in breaking down political, institutional, and economic barriers that excluded artists who lacked access to theatres, galleries, museums, and other elite and commercial art spaces. There was no need for a script, for copyright permission, or for legitimation from cultural experts. Suddenly, a performance could pop up anywhere, at any moment. The artist only needed his or her own body, imagination, and words to express ideas in front of an audience that sometimes found itself unexpectedly and involuntarily involved in the event.

Performance art—**anti-institutional, antielitist, anticonsumerist**—came to constitute, almost by definition, a provocation and a political act, even though the political could be understood more as a rupture and challenge, than as an ideological or dogmatic position.

Do women have to be naked to get into U.S. museums?

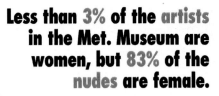

Less than 3% of the artists in the Met. Museum are women, but 83% of the nudes are female.

Statistics from modern and contemporary galleries, Metropolitan Museum of Art, New York, 2004

GUERRILLA GIRLS CONSCIENCE OF THE ART WORLD
www.guerrillagirls.com

The **Guerrilla Girls** (U.S.), an anonymous group of women artists, openly challenged the sexism and racism of museums that promoted the work of predominantly white male artists.

The space and time of performance can erase the borders between "life" and "art," between the "public" and the "spectator," between "politics" and "aesthetics."

It should not surprise us that the public sometimes does not know how to react to events that they come across, sometimes involuntarily.

A man wearing a mask walks into an expensive restaurant and sits down . . .

In the men's room, someone is reciting poetry . . .

These are just some examples of performances by Guillermo Goméz-Peña that succeed in confusing his viewers.

Performance, as acts of intervention, can interrupt the circuits of the cultural industries that create products for consumption. It is much harder to control bodies than to control television, or radio broadcasts, or Internet platforms. This is why regimes of power do everything possible to avoid and prohibit mass congregations and, in some places, the use of masks in public gatherings. Performance does not depend on texts or publishing companies (and it therefore eludes censorship). It does not need directors, actors, designers, or all the technical devices that theatre requires; it does not require special spaces to exist—it only requires the act (and sometimes the presence)

of the performer and his or her public. Sometimes the public does not know it is the designated spectator.

..

Eleonora Fabião (Brazil) walks through the city with her eyes closed—using her hands and feet to feel her way. *Toca Tudo* (touch everything) forces her to rely on strangers for help crossing the street and finding her way. This is a **PRECARIOUS** performance. She distinguishes precariousness from ephemerality: "If the ephemeral is transient, momentary, brief (the opposite of what is permanent), the precarious is unstable, risky, dangerous (the opposite of what is secure, stable, and safe). If the ephemeral is diaphanous, the precarious is shaky. . . . If the ephemeral rehearses death, precariousness lives life. If the ephemeral refers to the non-lasting, the precarious discovers that 'what is under construction is already a ruin.'"

Those who help her navigate through the city, or who watch her, may not know what the performance is about or why she is doing it. It's enough to know that it's a "performance."

2.4 Eleonora Fabião in her performance *Serie Precarios—Toco Tudo*, Festival Internacional de Teatro de São José do Rio Preto, São José do Rio Preto, 2012. Photo: Felipe Ribeiro

2.5 Julie Tolentino, *A True Story of Two People*. Photo: Debra Levine

Performance brings questions of scale into play. Some performances are created for a single viewer.

Julie Tolentino (U.S.) built a small box with one-way mirrors in a gallery and invited people to dance with her inside it: "A True Story about Two People, 2005. New York at Participant Inc." Debra Levine describes the one-on-one performance: "Moving to randomly shuffled songs, cricket sounds and silences, [Tolentino] waits for successive bodies to enter her space and move her as they wish. According to her rules, whether alone or with another, she must always be in constant motion. One at a time, people hold her, move her, confess to her and breathe with her. Each pairing and every absence in between pairings marks the movements and rests of the performance's encounters."[6]

There are also huge performances involving thousands of people that we might call "performances of magnitude."

Patricia Ariza (Colombia) directed *Mujeres en la plaza* (*Women in the Plaza*), a massive performance carried out by three hundred women affected by the violence in Colombia.

2.6 Patricia Ariza, *Mujeres en la plaza*. Hemispheric Institute Encuentro, Bogota, Colombia, 2009

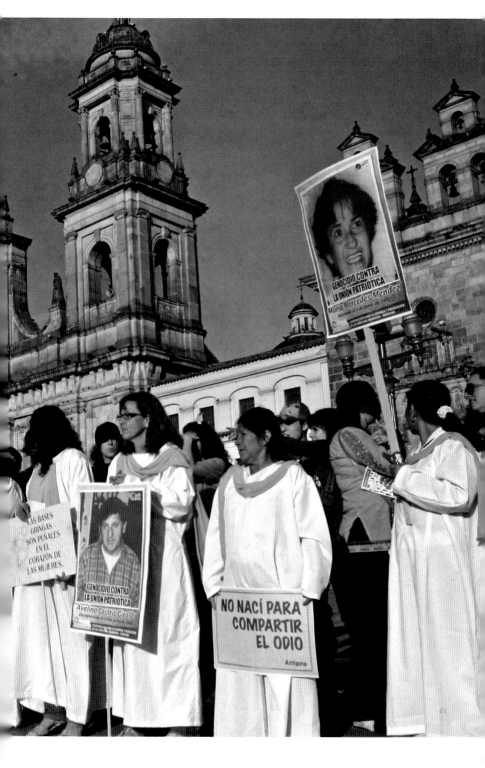

La Plaza Bolivar in Bogotá filled with thousands of observers, including relatives of the disappeared, making visible the scope of the country's violence.

No matter the scale of the event, performance is always mediated: the bodies of the artists and of the observer-participants reactivate an existing repertoire of gestures and meanings.

Normally, given the history of the predominance of the body in performance, one assumes that the artist is going to be the focus of the artwork. In Marina Abramović's 2010 retrospective, *The Artist Is Present*, at the MoMA in New York, the presence of the artist herself was the exhibit's central theme, as the title made clear. Many large galleries were filled with documentation, videos, photos, installations, and *reperformances* (enacted by other performers) of her iconic works. On another floor, Abramović sat in a chair in the museum's central atrium for more than two months, day after day, for the entire run of the exhibition, more than seven hundred hours in total. One by one, members of the public sat down in the seat opposite her, sometimes for hours, remaining silent. In this durational performance, one realizes that performance creates its own time and space not just for the artist but also for the participant who experiences the work. But this time and space is

2.7 Marina Abramović in *The Artist Is Present*, Museum of Modern Art, New York, 2010. Photo: Abigail Levine

much more complex than the mere presence of the artist. The performance is both intimate, one-on-one, and of great magnitude—announced throughout New York City on billboards and buses. In that piece, Abramović was both present and absent at the same time. Or, in other words, the many lives of performance coincided in this exhibition: its past, present, and future. The documentation stood as an archive of the past, and the reperformances pointed to a desire for a future in which Abramović's works would remain animated, even when the artist herself was no longer "present." The question of whether performance is essentially "ephemeral," whether it can survive its own moment, will be considered later (chapter 8), but here it is important to note that, for artists, there are many ways in which to be present or absent within a performance.

Performance, even when understood strictly as live art, is always mediated. Works function within systems of representation, and the body is one more media that transmits information and participates in the circulation of gestures and images. In this sense, it is the medium as well as the message. The Aztec priest, the Tarahumara shaman, the contemporary performer always negotiate between the present, the future, and the past, between here and the beyond, not only in relation to contemporary techniques or supernatural forces, but also in conversation with social, religious, and political values.

The relationship between artist and viewer is often complicated. The artist has many ways to be present and absent, and the viewer also has many possible positions, made evident by the many words that exist to designate this role: participant, witness, onlooker, audience (a term originally used to designate those who listen), spectator, voyeur, critic, observer, bystander.

The artist Álvaro Villalobos (Colombia) locked himself in a black box for forty hours. The audience could see him, but he could not return their gaze. Through his performance, Villalobos makes visible the population that is not seen: those who have been displaced by violence, the people who in Colombia are commonly referred to as "disposables." This performance inverts the gaze of the spectator: normally, those who are helpless watch us, but we avoid meeting their gaze. The challenge of this performance is not only what the artist is able to endure, but also what the audience is able to tolerate when confronted with a reality that it would prefer not to see.

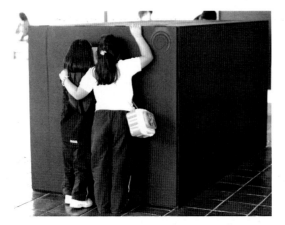

2.8 Two children look into the black box in which Álvaro Villalobos performed *Caja Negra*. The artist fasted silently for forty hours inside a wooden box at the Museo de Arte en la Universidad Nacional de Colombia. His performance was presented as part of the 2009 Hemispheric Institute Encuentro in Bogotá, Colombia. Photo: Mateo Rudas

2.9 Álvaro Villalobos in his performance *Caja Negra*. Photo: Niki Kekos

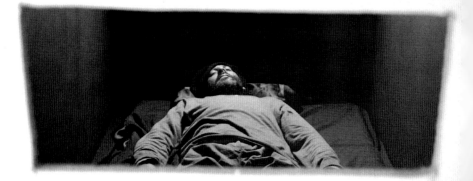

In other cases, it is not necessary that the artist be present in the flesh, in the same space as the audience.

In 1983, during the Pinochet dictatorship, CADA (Colectivo de Acciones de Arte) launched its campaign *No+* (*No More*). The work consisted of words written on walls around Santiago de Chile. For safety reasons, the artists had to disperse as soon as they placed their artwork, but they invited the public to complete the sentences:

No+ Dictatorship,

No+ Violence,

No+ Machismo

No+ Guns

NO+ . . .

One feels the force and the presence of the artist, even at a distance. The public is called upon to complete the performance.

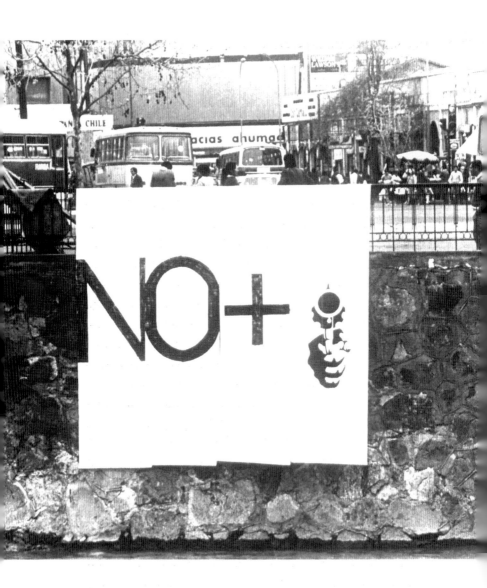

2.10 NO+ : CADA, citizen action, 1983. Santiago, Chile. Photo: Jorge Brantmayer

The NO+ has since been adapted for many other political stages around the world. As CADA member Diamela Eltit stated, **political art ceases to belong to the artists and becomes property of everyone who uses it**.[7] NO+ makes clear how performances are taken up, completed by others, and put back into circulation.

But there are other forms of "quoting" and transmitting performance from one time and context to another. Another CADA performance, *¡Ay Sudamérica!*, recalls and transforms the opening act of the 1973 coup lead by Pinochet, ushered in with airplanes bombing the Moneda (Chile's center of government). CADA rented six small airplanes and flew over Santiago de Chile dropping leaflets during the height of the repression. The leaflets stated that as long as human beings work to amplify the spaces of everyday life, they were artists. The power to work against the diminishment of life imposed by the dictatorship, and to imagine things otherwise, sustained many Chileans during the long years of Pinochet. Few people saw the act. But many more heard of it. The performance, *¡Ay Sudamérica!*, became iconic, central to the ways that many Chileans thought about their lives and their possible futures. The *seeing* did not limit the reach and efficacy of this work that continued to spread and augment in force. Amplification, after all, was the performance's reason for being. Chileans did not have the opportunity to see the videos until many years later when it became a part of Hemispheric Institute Digital Video Library (HIDVL).

Yet it seemed essential to know that the event had happened (that the tree had fallen in the forest, as Bishop Berkeley put it) without constraining the work performance does or delimiting it to the "now."

The performance continues to work long after it is "over."

For the fortieth anniversary of the coup another Chilean performance collective, Casagrande, painted silhouettes of military airplanes on the ground around the Moneda. They also started "bombing," dropping poems from airplanes. *¡Ay Sudamérica!* was an ephemeral performance, the way that every specific performance is ephemeral, and long-lasting at the same time—the way that performance can alter the ways we see the world. Performances, like art more generally, also engage and cite each other, offering another way of understanding events and historical change.

But does the performance event have to have happened?

As with just about everything we say about performance, we can also persuasively argue the opposite. Above I noted that it was crucial for our understanding of the enduring force of *¡Ay Sudamérica!* to know that the six artists had actually flown airplanes over the city during the violent dictatorship that claimed ownership of everything, including the Chilean skies.

2.11 Casagrande, silhouette of planes at La Moneda,
September 2014. Photo: X-Cam/Ariel Marinkovic

There are performances whose efficacy depends on the **IDEA** that it could happen. One example: The *potential* of the act sets everything else in motion. Ricardo Dominguez, one of the founders of Electronic Disturbance Theatre (EDT) and b.a.n.g. lab, was part of a team of activists/artists who designed the Transborder Immigrant Tool (TBT), a cell phone designed to help those crossing the desert of the U.S.-Mexico border region on foot find water and call for help if they needed it.

Although the TBT had not been developed and was never put in use, the symbolic and political efficacy of the unrealized act was so strong that Dominguez was demonized by right-wing politicians and the press and threatened with losing his tenured position at the University of California. Dominguez's critics were trying to stop something that hadn't happened, and they were decrying "an artifact that was not embedded in the real," as Dominguez put it. The idea of helping undocumented migrants, not the tool, proved powerful and radically altered the way in which power had to respond. The political efficacy of the nonexistent tool had, in fact, the performative force of the idea. The performance lay in its utterance, the announcement of an act that could be labeled everything from humanitarian aid to an act of terrorism.

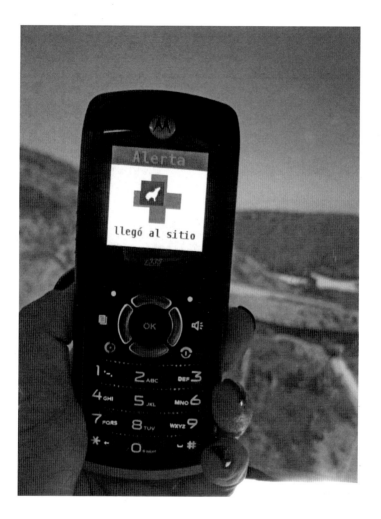

2.12 The Transborder Immigrant Tool, U.S./Mexico border, 2011.
Photo: Diana Taylor

Performance art, we see, challenges definitions and conventions. It transgresses barriers, breaks the frame, and defies limits and rules. So the only rule we might apply is the following:

Breaking norms is the norm of performance.

2.13 Eleonora Fabião, *Receptive Body*. The artist is painted by spectators during the performance. 2001 Hemispheric Institute Encuentro, Monterrey, Mexico. Photo: Lorie Novak

3

Spect-Actors

..

Performances often challenge the limits of artists. But

they also challenge those of their viewers.

Theatre practitioners have recognized that seeing is a way of

knowing. In Greek the *théātron*, or "place for viewing," is also

the place for theorizing. But theorists from Plato to the pres-

ent have also known that there is a politics to seeing, although

few agree on what that politics might be. For Plato, the skilled

artist or "charlatan" can "deceive children or simple people"

who can't distinguish between "knowledge and ignorance,

3.1 Lorie Novak, *Look/Not/Look*, 2011. Photo courtesy of the artist

reality and representation."[1] Aristotle affirmed the pedagogical and affective power of representation. Aristophanes in *The Frogs* pointed out that spectators were sometimes the object of political machination, rather than simply learning from it. While the notion that all vision is partial and mediated goes back at least as far as Plato's cave, the debates about what can and cannot be known through vision, and how spectators evaluate what they experience, continue into the present and are now further complicated by the prevalence of mediatized spectacles and interactive digital technologies.

There are many ways to participate in a performance. Rites require initiates; politics requires adherents; trials require witnesses; bourgeois theatre, according to Brecht, demands that viewers leave their critical capacities (along with their hats and coats) in the cloakroom. Military dictatorships aim to create docile individuals through a process I have called "percepticide,"[2] in which threats of atrocity and terror render us deaf, dumb, and blind. Better not see. Better keep quiet. Western theatre, practitioners such as Augusto Boal argue, has trained us to watch passively rather than to act. Cervantes makes fun of Don Quixote for not being able to distinguish between art and life when he attacks the wooden villain in the Maese Pedro puppet theatre. The English poet Samuel Taylor Coleridge posits that art depends on the "willing suspension of disbelief."[3] In theatre, that means the spectators' pleasure depends on temporarily believing what we know to be pretend. Whether seen as empowering or disempowering, no one contests the communicative power of theatre. Antonin Artaud extols the

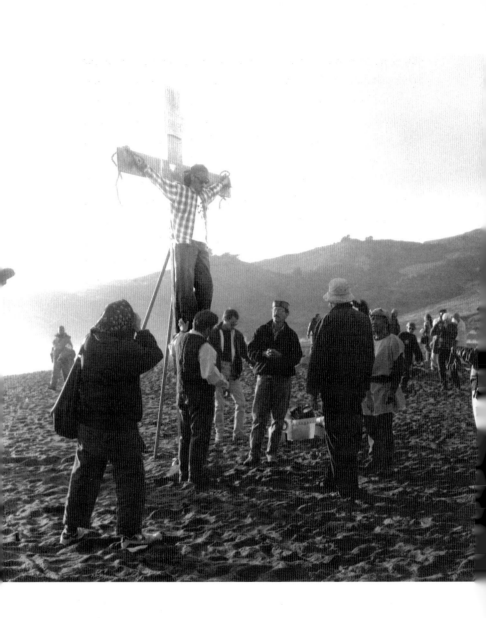

3.2 Roberto Sifuentes in *Cruci/Fiction*. Golden Gate Park, San Francisco, 1994. Photo: Cinthia Wallis

power of theatre, which, "without killing, provokes the most mysterious alterations in the mind of not only an individual but an entire populace." He understood, without the scientific evidence now offered by neuroscientists, that "our nervous system . . . responds to the vibrations of the subtlest music and is eventually modified by them in a lasting way. . . . The mind believes what it sees and does what it believes."[4] In politics, that means bystanders sense the "murderous alterations" and conclude that their survival depends on not understanding or recognizing what is actually happening before their eyes. All of these instances of seeing and not seeing respond to conventions. In commercial theatre and official performances, spectators are taught to refrain from intervening or resisting the hegemonic vision of persuasive drama, conflict, and happy endings; passive watching is usually part of the behavioral code for audience members during performances.

They—the actors, the heroes—act. We just watch.

...

Two men crucify themselves on wooden crosses planted in the border between the United States and Mexico, leaving written instructions for the audience to take them down from their crosses. The audience knows it is a performance and, following theatrical conventions, assumes that no one should intervene. The artists faint . . .

...

Michel Melamed (Brazil), in his piece *Regurgitofagia*, attached his arms and legs to electrified wires. A light bulb on the dark,

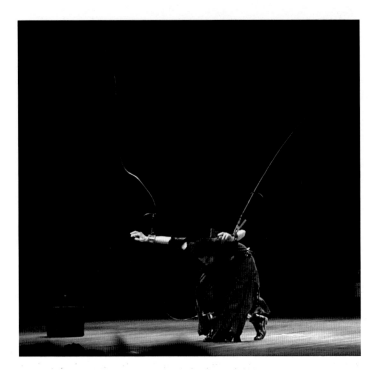

3.3 Michel Melamed in *Regurgitofagia* (*Regurgitophagy*).
SESC Ginástico, Rio de Janeiro, 2009

empty stage showed the level of the current. Every noise from the audience sent an electric shock through him. Throughout the performance, Melamed talked and joked and engaged the audience. Would audience members respond to him and laugh? Or, to avoid hurting him, would they sit silently? This performance raises many issues, especially in a country where ordinary citizens were tortured with electricity, not so long ago. Will the spectators play along with the violence? Will they walk out and refuse to participate, even though the noise of their leaving might cause him further pain? Is the performer, perhaps, enacting violence on his audience, forcing them into a "decision dilemma" that has no right answer, no good outcome? **Maybe, this piece suggests, there is no such thing as a "solo" or one-person performance.**

..

LOOKING CAN BE FRAUGHT. . . . Dangerous seeing, seeing that which was not meant to be seen, puts people at risk in a society that polices the look. The mutuality and reciprocity of the look, which allows people to connect with others, gives way to unauthorized seeing. Functioning within the surveilling gaze, people dare not be caught seeing. Better to cultivate a careful blindness. Performance can stage percepticide, the triumph of the atrocity that impels us to close our eyes. The spectacles of violence leave us speechless and blinded. We have to deny what we see, and in shutting our eyes, we become complicit in the violence that surrounds us. Like Oedipus, we cannot look at the world we have created.

For Boal, **SPECTATOR IS A BAD WORD!** Boal wanted to break with the convention of passivity for SPECTATORS and worked to convert them into **SPECT-ACTORS**, people capable of acting and interrupting the performance or changing the roles they've been assigned. Boal developed his famous Theatre of the Oppressed with theoretical arguments and exercises for training people to insert themselves in daily political scenes. In "Image Theatre," for example, he asks a group of five or six participants to stage an image of oppression. That done, he asks them to stage a new image—the ideal resolution to the earlier oppression. In the third and last image, he asks them to show how they get from here (problem) to there (solution). That simple exercise (among many he developed) helps participants become active agents, spect-actors.

Spectatorship can only be understood as functioning within systems and relationships of power. Though *spectator*—like other words for seeing such as *watcher*, or *voyeur*, or *witness*—sounds like a solitary, distanced position from the margins, it is prepositional. We are spectators *to, with, in, of . . .*

Louis Althusser, in *For Marx*, noted that "performance is fundamentally the occasion for a cultural and ideological recognition."[5] He broke down spectatorship into two main types—the distanced, on one hand, and identification, or that without distance, on the other. He rejects hegemonic distancing ("Mother Courage is presented to you. It is for her to act. It is for you to judge. On the stage the image of blindness—in the stalls the image of lucidity") as well as the identification model of view-

ing, which he critiques as reducing "social, cultural and ideological consciousness" to "a purely psychological consciousness." It's not just about you. Or me.

Bertolt Brecht, like Althusser and other Marxist theorists, argued for a critical, dialectical spectatorship. Brecht developed the concept of *Verfremdung*, meaning "estrangement" or "disillusion," to combat the alienation that workers felt within the increasingly mechanized systems of production. Take away the illusion, make the familiar strange, so that people can see with fresh eyes and act with critical lucidity.[6] He wants "the spectator's intellect free and highly mobile," able to respond thoughtfully to the situations presented onstage, rather than the "sleepers" he sees sitting in darkened theatres "as if in a trance."[7] We, "children of a scientific age," enjoy resolving the challenges we see before us. Therein lies the pleasure of theatre and spectatorship.

Writing around the same period, and also in response to the European fascisms of the 1930s and '40s, Antonin Artaud wants to "abandon the modern humanistic and psychological meaning of the theatre" and engage in a frenzied, extreme, and ecstatic theatre where spectators become participants, throwing themselves fearlessly into the unknown, the mystic and transcendent, "like victims burnt at the stake, signaling through the flames."[8]

Jacques Rancière, building on Brecht and Artaud, lays out the "paradox of the spectator": there is no theatre without a spectator, and the spectator is passive and bad. In both positions, he states, "theatre is presented as a mediation striving

for its own abolition." Debates have always called for either the sharpening of the spectator's critical faculties or, on the other hand, the abandonment of critical thinking for engaged participation. But as Rancière points out, seeing is also a doing; "viewing is also an action. . . . She observes, selects, compares, interprets. . . . She participates in the performance by refashioning it in its own way."[9]

Neuroscientist Vittorio Gallese would agree with Rancière's "seeing is a doing" because he studies human "mirror-matching systems." When we see someone doing an action, "our motor system becomes active as if we were executing the same action that we are observing."[10] "Action observation," he finds, "implies action simulation." Spectatorship is social and relational.

Arielle Azoulay (Israel) underlines a "spectator's responsibility," especially in relation to photography, and advocates the need for an "ethical spectator" to evaluate and take a stand on political realities.[11] She cautions us against leaving the photographer of the events, and the spectators, outside the frame; they (we) are all implicated in what is happening.

Georges Didi-Huberman (France) similarly argues that spectators/viewers have an obligation to see and to imagine. He writes that we owe it to the Holocaust's concentration camp prisoners who took photos for us *to look*—we are "trustees, charged with sustaining [those few shards] simply by looking at them."[12]

Performance can call spectators to action, but it sometimes puts them in very confusing, powerful, disempowering, or uncomfortable situations.

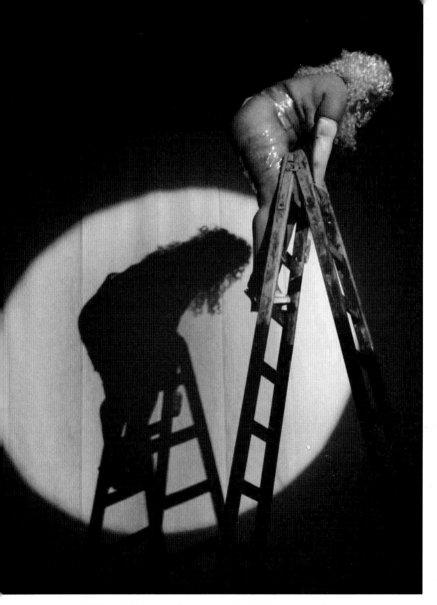

3.5 Nao Bustamante, *America the Beautiful*, presented at the 2002 Hemispheric Institute Encuentro in Lima, Peru. Photo: Marlène Ramírez-Cancio

La Congelada de Uva (Rocío Boliver, Mexico) sews the lips of her vagina shut, having first inserted a plastic figurine of Jesus. Why is she doing that? Or, better, what are we doing there, watching her? Her performance depends on the idea of consent: we understand that she and her audience are all present of their free will. The performance establishes complicity between exhibitionist and voyeur.

3.4 Rocío Boliver (La Congelada de Uva) performing *Cierra las piernas* during the 2003 Hemispheric Institute Encuentro in New York. Photo: Marlène Ramírez-Cancio

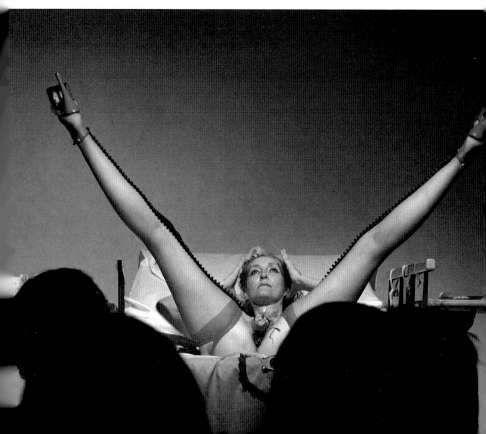

for its own abolition." Debates have always called for either the sharpening of the spectator's critical faculties or, on the other hand, the abandonment of critical thinking for engaged participation. But as Rancière points out, seeing is also a doing; "viewing is also an action. . . . She observes, selects, compares, interprets. . . . She participates in the performance by refashioning it in its own way."[9]

Neuroscientist Vittorio Gallese would agree with Rancière's "seeing is a doing" because he studies human "mirror-matching systems." When we see someone doing an action, "our motor system becomes active as if we were executing the same action that we are observing."[10] "Action observation," he finds, "implies action simulation." Spectatorship is social and relational.

Arielle Azoulay (Israel) underlines a "spectator's responsibility," especially in relation to photography, and advocates the need for an "ethical spectator" to evaluate and take a stand on political realities.[11] She cautions us against leaving the photographer of the events, and the spectators, outside the frame; they (we) are all implicated in what is happening.

Georges Didi-Huberman (France) similarly argues that spectators/viewers have an obligation to see and to imagine. He writes that we owe it to the Holocaust's concentration camp prisoners who took photos for us *to look*—we are "trustees, charged with sustaining [those few shards] simply by looking at them."[12]

Performance can call spectators to action, but it sometimes puts them in very confusing, powerful, disempowering, or uncomfortable situations.

ing, which he critiques as reducing "social, cultural and ideological consciousness" to "a purely psychological consciousness." It's not just about you. Or me.

Bertolt Brecht, like Althusser and other Marxist theorists, argued for a critical, dialectical spectatorship. Brecht developed the concept of *Verfremdung*, meaning "estrangement" or "disillusion," to combat the alienation that workers felt within the increasingly mechanized systems of production. Take away the illusion, make the familiar strange, so that people can see with fresh eyes and act with critical lucidity.[6] He wants "the spectator's intellect free and highly mobile," able to respond thoughtfully to the situations presented onstage, rather than the "sleepers" he sees sitting in darkened theatres "as if in a trance."[7] We, "children of a scientific age," enjoy resolving the challenges we see before us. Therein lies the pleasure of theatre and spectatorship.

Writing around the same period, and also in response to the European fascisms of the 1930s and '40s, Antonin Artaud wants to "abandon the modern humanistic and psychological meaning of the theatre" and engage in a frenzied, extreme, and ecstatic theatre where spectators become participants, throwing themselves fearlessly into the unknown, the mystic and transcendent, "like victims burnt at the stake, signaling through the flames."[8]

Jacques Rancière, building on Brecht and Artaud, lays out the "paradox of the spectator": there is no theatre without a spectator, and the spectator is passive and bad. In both positions, he states, "theatre is presented as a mediation striving

Nao Bustamante (United States) disturbs her audience with dangerous and shocking acts. She climbs a precarious ladder while bound up by packing tape and wearing high heels; her movement is dangerously inhibited.

In another performance, she covers her face with a plastic bag filled with water. Some people in her audience feel ethically obliged to pull it off her; they choose not to participate in the mutilation or possible destruction of the human body, whether or not it is being undertaken toward artistic ends.

Bustamante warns us: **"I'M NOT RESPONSIBLE FOR YOUR EXPERIENCE OF MY WORK."**

3.6 Nao Bustamante, *Sans Gravity*, presented at the 2003 Hemispheric Institute Encuentro in New York. Courtesy of the artist

Performances ask that spectators do something, even if that something is doing nothing.

Each performance anticipates its ideal response. The fourth wall asks the spectator not to intervene, to keep her distance, to remain seated to observe the artistic work. A demonstration asks that people come together in solidarity with a cause. During a march against the ongoing feminicides in Mexico, organizers requested that marchers place a flower on the body of the "dead" woman and commit to continue the struggle for peace.

..

There are performances that confuse the spectator, and others that terrorize us, blind us, turn us into pillars of salt. Still others, as Jesús Martín Barbero (Colombia) notes, are like a blow to the eye: spectators can no longer see things the way we did before.

Earlier, performance was defined as a "doing" and a "thing done." Now we need to add:

Performance is a doing to, a thing done to and with the spectator.

3.7 NO+ *Massacres*. Hemispheric Institute of Performance and Politics, San Cristobal de las Casas, Chiapas, Mexico, 2010. Photo: Moyses Zuniga

4

The New Uses of Performance

..

During the last thirty years, we have seen a proliferation of

the use of the word "performance." A recent Google search for

the word produced more than 630,000,000 results in English

alone. In many cases, the word is used synonymously with

capability, **achievement**, **execution**, or **output**.

Sunglasses, sneakers, computers, cars, drones, and military

systems boast of their performance qualities. Business manag-

ers are, according to one ad, "the greatest specialists in Human

Performance." There are training programs for the optimi-

zation of athletic performance." Sikorsky Military Systems claims that "no matter the mission . . . our goal is to supply state-of-the-art aircraft and the mission systems to maximize their performance." Do people or things behave or deliver in accordance with their potential, their promise? Across the board, it's "perform or else!"[1]

The challenge, performance theorist Jon McKenzie (U.S.) argues, "is to connect the performances of artists and activists with those of workers and executives and, further, with those of computers and missile systems." How is it—he asks us— "that performance comes out of the end of the 20th Century as a form of artistic resistance, as well as the dominant practice of business organization?"[2]

I would add politics to this mix.

Political advisers know that performance as STYLE (rather than ACCOMPLISHMENT) generally wins elections. Advisers ask whether a performance is effective or memorable, not whether it corresponds to verifiable facts. They know that a political performance needs to impel and move the public to action (for example, to vote) or, many times, to nonaction (not to judge their leaders by their actions). They train their candidates to learn their roles better than any actor does. The candidates rehearse and prepare. The gestures, style, and affect of charismatic politicians can produce concrete effects. **The public may respond more intensely to how a candidate *looks* and what she *does* than to what she *says*.**

Although the image of a leader is a mediated product, the public demands that this image reflect its own values, ideals, and

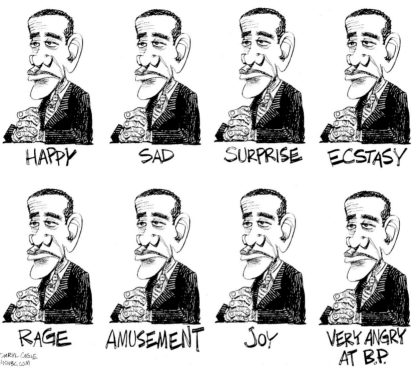

4.1 Drawing by Daryl Cagle. www.politicalcartoons.com

aspirations. People want to be able to identify with him or her. "Evita loves us." "Bush is a regular guy, like me or my neighbor." When a politician doesn't show emotions, she strikes us as distant, ineffectual—"not one of us."

Cases in which style leads to electoral results demonstrate that performance, however much it is rehearsed and staged, can have "real" results, including devastating ones. **Performance is not judged in terms of TRUE/FALSE; BEING/PRETENDING. INSTEAD, THE AFFECTIVE IS THE EFFECTIVE.**

Mexican theorist Rossana Reguillo has noted the move toward the depoliticization of politics through a politics of passion that exceeds (and rejects) traditional institutions.[3] The politics of passion explains the resurgence and even centrality of the body in politics. But unruly acts and passions cannot be limited to the "outside"—they cross ideological and structural bounds, showing the fears, anxieties, prejudices, and hopes that animate the attitudes and actions of the state itself. While usually commentators assign affect to the opposition, characterizing those outside established political systems as irrational or angry, what Freud observed just after World War I remains true today: "It would seem that nations still obey their passions far more readily than their interests."[4]

In Mexico in 2006, millions of people jammed into the Zócalo (Mexico City's central square) to protest the fraudulent election returns. For fifty days, people slept there in tents and

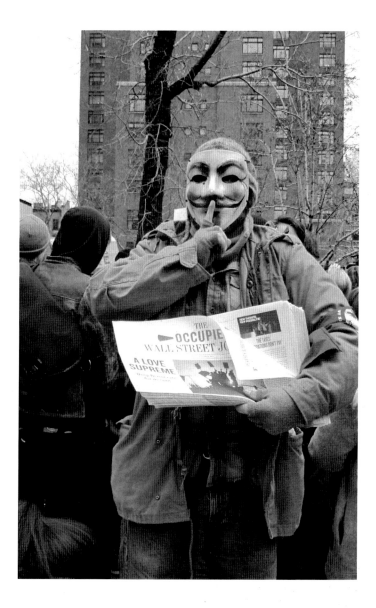

4.2 Anonymous at Occupy Wall Street, 2012. Photo: Diana Taylor

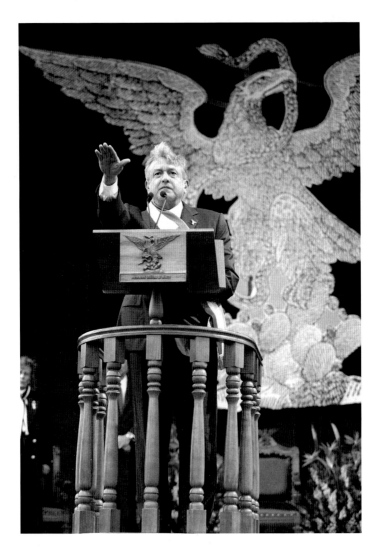

4.3 Andrés Manuel López Obrador. From the archives of *La Jornada*

4.4 (*opposite*) El Planton, Zócalo, Mexico City, July 2006. Photo: Diana Taylor

clogged the main boulevard of Mexico City to demand a recount. As part of the nonviolent resistance, Jesusa Rodríguez organized over three thousand performance acts to call attention to the group's claims for legitimate democracy. A performance coup of sorts happened when Andrés López Obrador, the candidate who "lost" the fraudulent election, was sworn in as the "legitimate president" in a "pretend" inauguration—"pretend," that is, in relationship to the "real" one that was outperformed as illegitimate.

The "real" official swearing-in could not be celebrated in a public place for fear of popular outrage. Rather, it took place during a four-minute ceremony in the midst of a congressional brawl.

But the megaperformance, the living and cooking in open tents in one of the world's largest cities, enacted a vision of participatory democracy and a safe shared space that in Mexico has never in fact existed.

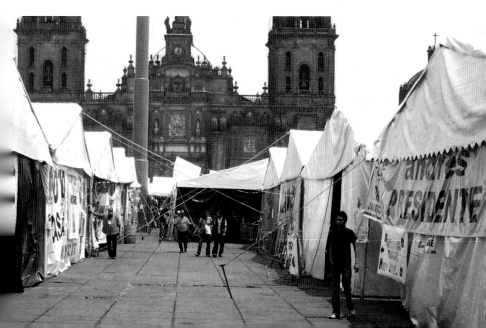

In the United States, the Tea Partiers, Birthers, Occupy Wall Street groups, and many others perform their politics rather than simply voting for them every four years. At times political enactments become extremely heated and theatrical. Responding to one such moment, Jon Stewart of *The Daily Show* called for a "Restore Sanity Rally" on the Mall in Washington, asking the 70–80 noncrazed percent of the population to "take it down a notch." One of the signs for that rally was **"I disagree with you, but I'm pretty sure you're not Hitler."**[5]

The performance of politics takes place within specific contexts and scenarios that create their corresponding subjectivities.

We usually think of bodies as central to performance, as protagonists and agents of social change and artistic intervention. We must accept, however, that performance also functions within systems of subjugating power in which the body is simply one more product. Colonialism, dictatorships, patriarchies, torture, capitalism, religions, globalism, and so on, construct their own bodies.

The human body has changed (again, and always . . .).

THE BODY, yes, but what body? Whose body? How does "the body" get constructed?

4.5 David Lozano (Colombia), *Marca y ego: Oficios para el cuerpo*.
Hemispheric Institute Encuentro, Bogotá, Colombia, 2009

The 1950s body of Evita is very different than the muscular, enhanced body of Madonna playing the role of Evita in 1996. A New York Health and Racquet Club ad featuring a wimpy man with long hair reminds us that in the 1970s "only cars had muscles." **In late capitalism, the body is both the consuming subject and the object of consumption**. It's a thing we have and a thing we are, a product of systems of regulation (see **PERFORMATIVITY**). While this has always been the case and people have always internalized the roles into which they were inducted at or before birth (as Simone de Beauvoir notes, we are not born women, we become women), the external controls seem increasingly obvious. The consuming subject subjects itself to objectification—people starve themselves to fit the image of the Photoshopped bodies of the anorexic models

in ads. The body is a project. It can be worked on and perfected. A cover of a women's health magazine promises: "Your Best Body Ever! Get It Now! Keep It Forever!"

In self-consuming capitalism, "You" exist only as representation, one more thing in the accumulation of goods and cultural capital. "Tell me how you shop and I'll tell you who you are, whether in Shanghai or San Francisco," writes Roger Cohen in "Premiumize or Perish."[6] It's not just the handbag that's for sale, it's the image of You: "You can now order regular M&M's online with an image of your face on them."[7]

In our capitalist vocabulary, **YOU** is an object. **YOUIFICATION** is the process of becoming an object.

The desires and personal aspirations we call our own can be produced by a *desiring-machine* quite distant from (and sometimes in violent conflict with) our own good.[8]

Rocio Boliver (Mexico) makes evident the violence that forges the construction of the feminine in a society in which beauty, as an image of perfection, transforms people into grotesque and dehumanized beings.

Economic performance, sexual performance, the performance of "the body," discursive performance, technological performance, political performance, aesthetic performance: these phenomena work together, interconnected to such a degree that it's difficult, if not impossible, to understand one without the other.

4.6 Rocío Boliver (La Conjelada de Uva), *Mascarillo rejuvenecadora*, 2013. Photo: Alfredo Beltrán

The performances of capitalism differ from those of totalitarian or authoritarian dictatorships. In the "**concentrated**" spectacle of military dictatorships, as Guy Debord observes, power is made visible, identifiable.[9] It has a face and a name.

In contrast to this concentrated power, the "**diffuse**" spectacle of late capitalism, which Debord discusses, is much more difficult to locate and identify.[10] This power resides everywhere, in our products, in networks of circulation, in the behaviors and desires that belong to the illusory world of success that capitalism renews daily in our social imaginary.

The "**integrated**" spectacle combines the concentration of power in a few identifiable people and corporations with the diffuseness of its effects. Who is responsible for what?

Performance, according to a Mercedes-Benz commercial, "isn't about doing something well . . . it's about doing EVERYTHING well." Here the car does the doing.

We live in a world saturated with models and instructions for success: **the *how to* of performance**. How to get people's attention, how to triumph, seduce, command . . . Everything, it seems, has become a symbolic extension for "our" idealized bodies. Bodies (ideally, of course, the boring-already naked women and men) are used to sell us everything else. At the same time, though, this system sells us bodies and fantasies far removed from our own. The technological body is the new human body, eroticized, "designed to thrill" according to an

4.7 Military junta, Argentina, 1976. Photo: Guillermo Loiacono

4.8 The new cogito: i text therefore IM. Photo: Diana Taylor

Audi commercial.[11] Ideals of beauty and human prowess have been melded with the cyborg—the bionic is *en vogue*.

According to our society of the spectacle, then, the body is a thing you can acquire, train, perfect, design, display, and preserve into perpetuity. The human body has been converted into a project to be realized, one more performance within a system of representations mediated by new digital technologies. Intersubjectivity is possible only through technology.

The new cogito: I text therefore IM.

Ricardo Dominguez and the members of the Critical Art Ensemble argue that, even as we celebrate this power of self-definition, we feel anxiety brewing:

> *This anxiety emerges less from the curious no-position of having no fixed attributes, but more from the fear that the power driving this reinvention resides elsewhere. One senses that there are hostile, external forces, rather than one's own powers, that construct us as individuals. This problem becomes more and more complex in the context of our techno-culture, in which people inhabit virtual theatres that are foreign to their daily lives yet, at the same time, have an enormous impact on them. Abstracted representations of the self and the body, separated from the individual, are simultaneously present in many locations, interacting and recombining with others, all beyond the control of the individual and, many times, in ways that harm them.*[12]

As Paul Beatriz Preciado notes, "the changes in capitalism that we are witnessing are characterized not only by the transformation of 'gender,' 'sex,' 'sexuality,' 'sexual identity,' and 'pleasure' into objects of the political management of living [. . .] but also by the fact that this management itself is carried out through the new dynamics of advanced technocapitalism, global media, and biotechnologies."[13]

At the same time, new technologies clearly offer us new options for developing non-normative subjectivities. Performance artists like Stelarc (Australia), among others, have experimented with radical interventions on their bodies.

Stelarc added an ear to his body with plastic surgery; he added an arm with electronic cables; he has externalized internal parts of his body using yet other technologies.

He explains:

> The body has been augmented, invaded and now becomes a host—not only for technology, but also for remote agents. Just as the internet provides extensive and interactive ways of displaying, linking and retrieving information and images it may now allow unexpected ways of accessing, interfacing and uploading the body itself. And instead of seeing the internet as a means of fulfilling out-moded metaphysical desires of disembodiment, it offers on the contrary, powerful individual and collective strategies for projecting body presence and extruding body awareness. The internet does not hasten the disappearance of the body and the dissolution of the self— rather it generates new collective physical couplings and a telematic scaling of subjectivity. Such a body's authenticity will not be due to the coherence of its individuality but rather to its multiplicity of collaborating agents. What becomes important is not merely the body's identity, but its connectivity—not its mobility or location, but its interface.

4.9 Stelarc, *Ear on Arm*. London, Los Angeles, Melbourne, 2006. Photo: Nina Sellars

Artists Micha Cárdenas and Elle Mehrmand (U.S.) use digital technologies to challenge traditional forms and norms of sexual identity:

> In technésexual, the performers enact playful, erotic scenes in a physical space and project into virtual space, using apparatus to extend the reach of their hearts to publics in the room and in Second Life. They connect the two realities through audio, and explore the liminal spaces between these overlapping spaces. Technésexual opens debate around multiple sexualities beyond restrictive LGBT categories (lesbian, gay, bisexual, or transgender) and of homo/heterosexuality. The mixing of realities creates a parallel to the experiences of the artists themselves, one that mixes genders and sexualities. The virtual worlds like Second Life facilitate the development of new trans-real identities, permitting ways of relating to each other that we have yet to imagine.[14]

Technological transformations offer new obstacles and new opportunities for expression.

4.10 Micha Cárdenas and Elle Mehrmand, *Technésexual*. Los Angeles
Contemporary Exhibitions, 2000. Photos courtesy of the artists

We live simultaneously in various temporal states and various spaces of performance.

It is not only the body that has changed. **Our sense of space has also been altered.** The digital has become an extension of the human body. **We live simultaneously in a "real" world and a "virtual" one.** This is not only an effect of the Internet. Members of the most marginalized communities in the Americas have cell phones to communicate with their loved ones abroad. They send birthday videos and organize parties to share important events with those who have "crossed over"— undocumented border crossers, in this case. They live across various spaces and time zones simultaneously.

We all have electronic or "data" bodies or doubles. Authorities can access our migration information, our marital status, our health records, our bank records, and much more, simply by consulting a computer, whether or not we ourselves have a computer. The electronic body is more powerful than the body of flesh and bone—we can be denied health coverage, the right to travel, and much else based on digital records. Just ask Critical Arts Ensemble.

At the same time, **we participate actively in this hybrid world.** Many of us have bank accounts with secret passwords, we find our friends on Facebook, and we learn to sing and dance by watching videos on YouTube. We are compelled to participate, but we also participate willingly. What if someone had

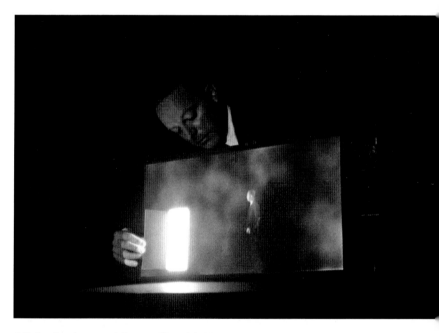

4.11 Stephen Lawson of 2boys.tv (Canada), *Phobophilia*. Hemispheric Institute Encuentro, Bogotá, Colombia, 2009. Photo: Julio Pantoja

told me twenty years ago that I would have a device attached to my body that could pinpoint where I was at all times? That it could read my messages even if the device was not turned on? I would have carried on with exclamations about Big Brother, dystopias, and "over my dead body." Now I cannot live without my cell phone.

The digital has forced us to name and delimit the "real." These days we must distinguish between "real" space and the "virtual," our life and "second life," the universe and the digital metaverse. The "flesh" body is not the same as the very powerful electronic data body. "Real time" is not the same as the present. "Live" is not the same as alive. An online community is not the same as a group of people.

As our bodies and sense of self morph, so does much of what counts as embodied knowledge.

We live, Debord observed fifty years ago, in the society of the spectacle of late capitalism: "The spectacle is the society itself, a part of the society, and an instrument for its unification."[15]

Since 9/11, the society of the spectacle in the United States has been saturated with talk and images of "terror." The physical enactment of terror takes place every day, and we rehearse and remember disaster every time we move from one place to another, even if the rituals of preparedness (like the old "duck and cover") are completely meaningless in terms of se-

curing public safety. At the airport, we are asked to take off outer layers of clothing and shoes and to throw water bottles into the trash. We are scanned, eyed, patted down, sometimes more than once. We perform terror everyday; we incorporate it. I am asked to show my ID to the public safety officer every time I enter my office. The guard never looks at my ID, but my performance of obedience, my willingness to conform to the arbitrary and absurd injunction, proves that I am probably a safe bet for admittance. Still, the barrage of homeland security signs—"If You See Something, Say Something"—caution that we are also being co-opted into a widespread surveillance system where we are asked to be vigilant, to call out the enemy. The scenario is even more powerful for Muslims or undocumented workers who know themselves to be the pretext and the prey. There is no neutral place, no nonwar. The politics of fear governs the willing and the unwilling.[16]

The phantasmagoric war on terror needs, and produces, its own bodies: a "face of the enemy." I have a deck of playing cards with all the bad men's faces on them.

After the release of the Abu Ghraib photographs, stores in the United States started selling sex toys and S&M and Halloween costumes that parodied them. Fashion models were shown hanging in stress position to advertise chic brands of pants. Entire photo shoots in fashion magazines displayed models being violated. These images circulate so readily, in so many contexts, that the political violence gets entangled with eroticism, consent, commerce, and play. The criminal reality is magically evacuated.

4.12 New York City subway campaign "If You See Something, Say Something."
Photo: Abigail Levine

We know what is meant by "money laundering." Here we are confronted with "image laundering."

Images circulate again and again until they lose all political force.

Images circulate again and again until they lose all political force.

Images circulate again and again until they lose all political force.

Images circulate again and again until they lose all political force.

But performance, unlike Debord's spectacle, is multidimensional. It offers the possibility of acts of contestation as well.

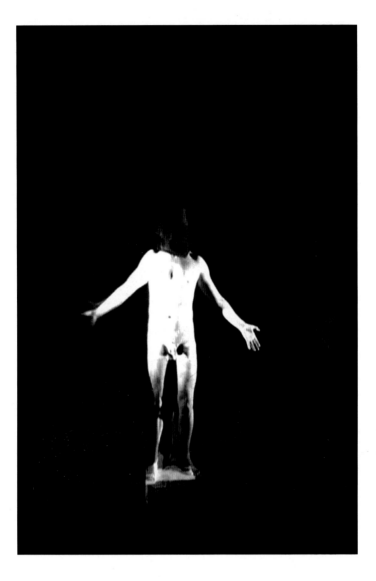

4.13 Stephen Lawson in 2boys.tv (Canada), *Phobophilia*. Hemispheric Institute Encuentro, Bogotá, Colombia, 2009. Photo: Marlène Ramírez-Cancio

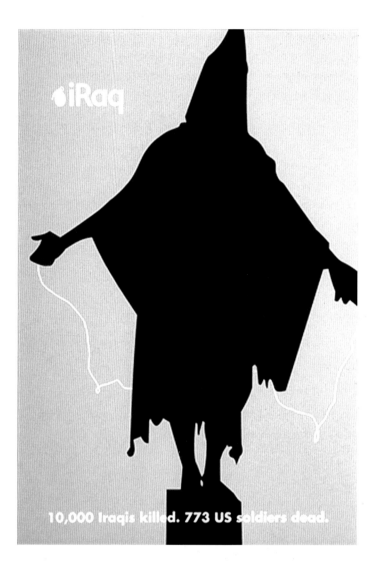

4.14 iRaq poster by Forkscrew Graphics, Los Angeles, 2004

We can recontextualize, resignify, react, challenge, parody, perform, and reperform differently. That is the promise of performance—as aesthetic act and as political intervention.

Human bodies do not simply embody these new spectacular subjectivities; they also activate a critical tension with them. The performance group 2boys.tv (Canada) demonstrates various conditions of the human body: its fragility and vulnerability, Giorgio Agamben's concepts of *Homo sacer* and the nonperson, the body that suffers and dies, the body made invisible, but also the body as the zone of confrontation between political, religious, and economic powers.

Artists like 2boys.tv remove our blindfolds, demanding that we confront our reality.

These defiant performances and images also circulate in the public sphere, making visible the violence that others try to minimize.

The battle to control actions, bodies, images, scenarios, and explanatory narratives rages on.

5

Performative and Performativity

..

Performative

As we have seen, the body (with all the problems associated
with it) occupies a privileged site in performance. But language
also plays an important role. In order to get married, a couple
has to say **I DO** and the officiant has to pronounce them mar-
ried before the act can be officially recognized. In a trial, the
jury must pronounce a verdict before the judge can hand down
a sentence. We might add incantations and witches' curses if
we trust in their transformative powers. These cases, which

the British philosopher J. L. Austin calls "**PERFORMATIVES**," demonstrate the ways in which language can become **ACTION**. Words, in certain contexts, actually **DO** things. In the case of Austin's performatives, they have real-world, even legal, repercussions. More than simply a description of an act, the language becomes the "act itself." **But here too, conventions are crucial**. Austin adds: "Speaking generally, it is always necessary that the *circumstances* in which the words are uttered should be in some way, or ways, *appropriate*, and it is very commonly necessary that either the speaker himself or other persons should *also* perform certain *other* actions, whether 'physical' or 'mental' actions or even acts of uttering further words."[1]

As with performance, performatives are all about the frame.

Let us take a look at *Wedding* by Liliana Felipe and Jesusa Rodríguez:

> *Jesusa and Liliana strike a Fontainebleau pose.*
>
> Priestess: (to Marcela) Now tie them up so that the rope holds.
>
> (*Marcela ties the rope.*)
>
> Priestess: Now we'll share promises. Liliana Felipe, do you solemnly swear to take Jesusa to buy Chiandoni ice cream every time she asks you to?
>
> Liliana: I do.
>
> Priestess: Jesusa Rodríguez, do you solemnly swear to control your motor mouth and go to the supermarket when, or before, Liliana asks you to?

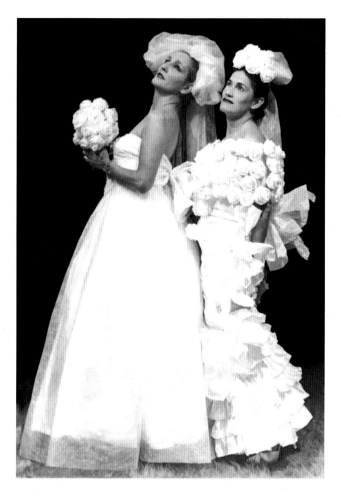

5.1 Liliana Felipe and Jesusa Rodríguez, *Wedding*,
Mexico City, 2001. Photo: Lourdes Almeida

Jesusa: I do.

Priestess: Having agreed to fulfill each others' desires, and conscious that loving someone means making them happy, you may kiss each other for the benefit of the press.

(The brides kiss.)

Words, like ropes, can bind us. But **PERFORMATIVES**, according to Austin, only function in circumstances that abide by specific conventions. For example, in the case of the wedding, the "priest" has to be a legitimate officiant, legally authorized to marry the couple. The couple also has to act in good faith. One cannot, for example, be married to someone else, cross one's fingers, or wink an eye. In short, the brides need to be sincere when saying **I DO**. Those present at the ceremony must serve as responsible witnesses, legitimating the proceedings. These values and conventions must be upheld in order for the couple's "I do's" to hold legal authority. Performatives do and promise. Jesusa and Liliana's wedding, a performative, cannot be held to be "true" or "false." Did they get married? Yes. Was the marriage legal? No. Or better, not that time.

The word "performative," then, has a very specific meaning. It is not, as some use it, the adjective for the word "performance." For this, I have proposed the word "**performatic**" as an adjective for performance. A lecture may be performatic (theatrical) without constituting a legal act.

When the required conventions for a performative are not in place, or not recognized, or parodied, what results may be a theatrical work, a farce, an example of performance art, a rebellious act of noncompliance, a mockery, a mess, or a joke—*choteo*, as they say in the Caribbean, or *relajo* in Mexico. Everyone has names for it.

In *Phenomenology of the Relajo*, Jorge Portilla writes that relajo (translated as "fooling around" or "disruptive acting out") "is not a thing but a behavior, a kind of collective mocking, reiterated and sometimes thunderous." Portilla points to three characteristics of relajo that discredit the legitimacy of authorized conventions: first, "there is a displacement of attention; secondly, a person positions him or herself in opposition to, or in a position of non-solidarity with, the values that are proposed; and, finally, an action manifested in words or gestures invites others to join the person in her or his opposition. Relajo, an intimate act of negation[,] . . . is an act of opposition or non-solidarity in the face of certain values and the community that upholds these values."[2]

One immediately sees the almost irresistible possibilities for disruptions or things that can go wrong within the conventions of the performative.

In 1968, during the height of the student protests, Mexican civil servants were required to crowd into the Zócalo, Mexico's massive central square, to show their support for the government. "But in a spontaneous gesture of rebellion, the bureaucrats turned their backs on the official tribune and began to bleat like a vast flock of sheep, forcing the authorities to dis-

perse them with armoured tanks and infantry."³ Francis Alÿs's (Belgium/Mexico) 1997 video *Cuentos patrióticos*, or *The Multiplication of Sheep*, paid tribute to that moment of disruption, the antiperformative, the relajo.

For Austin, the **HAPPY PERFORMATIVE** is a linguistic act that works and accomplishes its objectives within its context and authorized codes. But, as Tolstoy noted before him, there are many ways of being "unhappy." Misfires refer to acts that could not be achieved or completed because the necessary conventions and conditions were not in place—same-sex marriage was not legal in Mexico at the time Jesusa and Liliana married the first time. Abuses, for Austin, refer to acts that were achieved but with the wink of the eye. Sorry, I forgot to mention I was already married.

Without going into Austin's full "doctrine of the Infelicities" (14), we can say that Liliana and Jesusa's performatic wedding in 2001 was a happily *unhappy performative*. The priestess was not authorized to marry them, and the brides could not wed under the Mexican law of the time. But their wedding was efficacious and joyful nonetheless, held on Valentine's Day, on the eve of what is known as the "cowboy summit." Photographs in major newspapers of the smiling brides greeted U.S. president George W. Bush as he arrived in Mexico on February 15 to meet with Vincent Fox, president of Mexico. The women mime and queer the language and assumptions of heterosexist marriage at the very moment the two cowboys exercise their own powerful, authoritative performatives. "America," invoked by these presidents, is a very powerful performative.⁴ Pure relajo.

Jesusa and Liliana's legal marriage in 2010, after same-sex marriage was approved in Mexico City, was a happy performative—a very, very happy one, indeed!

Jacques Derrida, in *Signature, Event, Context*, underlines that the power of the performative lies not in individual agency— say the power of the justice of the peace or the jury members or the judge—but in the conventions themselves. "Could a performative utterance succeed if its formulation did not repeat a 'coded' or iterable utterance?"[5] Performatives, like performance, is "never for the first time," but always, as Derrida puts it, "citational."

...

Performativity

It's a Girl!

Performativity, Judith Butler states, "must be understood not as a singular or deliberate 'act,' but, rather, as the reiterative and citational practice by which discourse produces the effects that it names."Gender identity, for her, is not a theatrical enactment or performance— trying on gender identities as if they were outfits. Nor is it a performative in the Austinean sense in which a "subject brings into being what s/he names."[6] Rather, it refers both to the entire regulatory system that produces gendered subjects through a series of normative behaviors and to the possibility of response: **"performativity describes both the processes of being acted on, and the conditions and possibilities**

5.2 Ultrasound of Marlène Ramírez-Cancio and Jonathan Milder's baby girl

for acting, and that we cannot understand its operation without both of these dimensions."[7]

When we say "It's a GIRL!," the baby is born into a discursive practice that shapes how "she" will be viewed by others, what behaviors and identifications will be deemed appropriate, what other options or identifications will be "foreclosed" or "disavowed" as abject. This system predates "her" and exerts pressure on "her" even as she comes into being.

..

Here too, of course, people contest normative behaviors. Bodies rage. Various forms of embodiment struggle for dominance. Peggy Shaw, part of Split Britches, performed *The Menopausal Gentleman* in 1998.

Dressed in her suit and tugging on her tie, Shaw reveals:

> *It's hard to be a gentleman in menopause . . .*
> *Menopause is all it's made up to be*
> *. . .*
> *The reason I like the word gentleman is how refined,*
> *and detailed and consistent it is.*
> *The opposite of how I feel.*
> *I'm erratic on the inside and I try to be consistent on the*
> * outside,*
> *so that I appear perfectly normal.*
> *Mixed with the sweat.*[8]

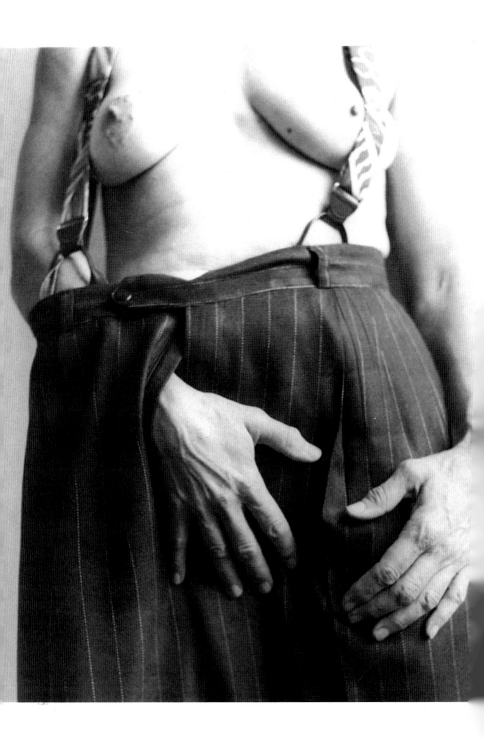

Animatives

Inspired by acts of disruption, relajo, and political contestations to the authoritative performative, I started thinking about what I have come to call "animatives." Performatives and animatives only ever work together. Performatives, as Austin made clear, function only within the realm of "appropriate" circumstances and behaviors. Therefore those conventions need to be secured and guarded—the forces of the inappropriate and disruptive endlessly put pressure on the frame. Animatives, as I conceive of them, are the "inappropriate" response to a performative utterance. They challenge or exceed discursive formulation. Animatives are part movement, as in "animation," and part identity, being, or soul, as in "anima" or "life." The term captures the fundamental movement that is life (breathe life into) or that animates embodied practice. Its affective dimensions include being "animated" as in lively and engaged. It also means being affectively "moved." *Ánimo* in Spanish emphasizes another dimension of the Latin animatus: courage, resolve, and perseverance. It refers to a cheering on and a cheering up. Animatives thus are key to political life. As Castells reminds us, "Emotions are the drivers of collective action."[9]

E-motion = Affect in movement.

Art and activist practices often disrupt performatives. Las Yeguas del Apocalysis (Mares of the Apocalypse, composed of

5.3 Peggy Shaw in *Menopausal Gentleman*, 1997. Photo: Eva Weiss

Francisco Casas and Pedro Lemebel, two radical and brilliant gay performers in Chile) were feared at literary and art exhibits given their relish for scandal and their propensity for crashing self-declared highbrow events. "They were not invited to the meeting of intellectuals with Patricio Aylwin (president of Chile from 1990–94) just before the elections of 1989, but they came anyway. They came onstage wearing high heels and feathers and extended a banner that said 'homosexuals for change.' Upon coming down from the stage, Francisco Casas jumped on then senatorial candidate, Ricardo Lagos, and gave him a kiss on the mouth."[10]

The efficacy of performatives depends on the acknowledgment/agreement of those in attendance. And the addressee always enacts a position—it might be one of agreement or consensus; it might be one of disidentification or radical rejection. The thousands of people living in Zuccotti Park during Occupy Wall Street overtly rejected Mayor Bloomberg's use of performative edicts, legal decrees, and official utterances backed by an overwhelming police presence. I use these terms, then, not to illustrate clear-cut distinctions between some high/low, good/bad, elitist/populist, "real"/"pretend" understanding of politics. But recognizing the force of animatives helps explain the degree to which traditional political hierarchies, structures, and legitimating discourses have been upended by disruptions enacted from and on the ground.

Bodies make their own claims in ways that cannot be adequately understood by looking primarily at linguistic paradigms. **Political bodies are amplified bodies—expanded by the mission, emotion, and aspirations that animate**

them. Protestors such as those in Occupy Wall Street understand themselves as embodying a historic movement. As bodies physically jostle each other marching down streets, people feel together in a shared struggle for justice. The crowded space literally forces people to communicate and rely on each other. As Judith Butler points out, "No one mobilizes a claim to move and assemble freely without moving and assembling together with others." Bodies also perform and transmit their own politics: think of the "mic checks." As bodies, we are "networked"—connected, extended into our surrounding environment. Embodied actions are less containable than discursive practice. As opposed to the media, controlled in large part by corporate interests, bodies serve as their own form of mediation. If we deride affect, we neglect vital aspects of civil disobedience—the visionary, the communicative, the emotional, and the contestational.

The Occupy Wall Street movement marks the force of the animative in relation to the performative in other ways as well. Critics called on the protestors to name their demands! Slavoj Žižek, who was against the protests until he was for them, accused protestors in the United Kingdom (before Occupy) of being "thugs" whose "zero-degree protest" was "a violent action demanding nothing."[11] Later, of course, Žižek called for an "occupy first, demand later" strategy—animatives before performatives.[12] The occupation of public space with their tents, libraries, meeting spaces, food centers, digital communication centers, and much more caught on around the world. These animated gestures enact a politics of massive unified presence. So did Occupy Wall Street's unwillingness to make a demand,

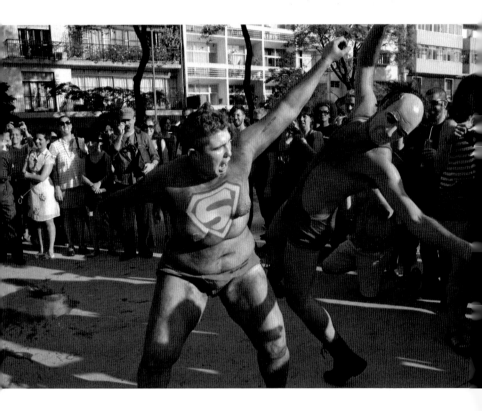

5.4 Ariel "Speedwagon" Federow was with participants of Marcos Bulhões's "Second Skin" workshop, and Lucas Oradovschi was with Coletivo de Teatro Operacões, in "A Cena é Pública." Photo: Julio Pantoja. 2013 Hemispheric Institute Encuentro, São Paulo, Brazil

to narrow their force to one or more specific claims. But here again, the play for an expanded political arena works only if others become involved.

Embodied actions challenge onlookers. Revolutions and transformations succeed when bystanders join in.

But like all else related to performance, animatives are in themselves neither good nor bad.

Animatives, linguistically so close to animation, offer a key insight into understanding performance and/as politics. Sianna Ngai explores what she calls "animatedness" or the "non-stop technology" of cartoons and animations as "unusually receptive to outside control." Control, she states, comes from the outside, as the inanimate body usurps the "human speaker's voice" and agency.[13] Animatives can refer to the promise of antielitist practices, such as Occupy Wall Street and its 99%, but they can also refer to less celebratory actions taking place in the messy and often less structured interactions among groups and individuals. The crowds of protestors that made up Occupy Wall Street, for example, were framed by the media as racialized rabble manipulated by outside forces.

Who controls whom?

Animatives encompass embodied, at times boisterous, at times violent, contradictory and vexed behaviors, experiences, and relationships. This, then, is the realm of the potentially chaotic, anarchist, and revolutionary that Jack Halberstam refers to as "the wild," that which "disturbs the order of things and produces new life."[14] Or, of course, its other.

6.1 Mapa Teatro (Colombia), *Witness to the Ruins*. Hemispheric Institute Encuentro, Buenos Aires, Argentina, 2007. Photo: Julio Pantoja

6

Knowing through Performance:
Scenarios and Simulation

..

Performance is not only an art form, an activist inter-

vention, a business management system, or a military

exercise. It provides a lens and framework for under-

standing just about everything.

The "as if" and "what if" qualities fundamental to performance

have become central in current military training programs,

political practice and protest, artistic performance, theme

parks, museums and memorial sites, and other areas that elicit

experiential engagement from participants and visitors. The hypothetical, conditional, and speculative mode of the subjunctive is key in knowledge production and transmission.

"Performance," as Jon McKenzie notes, has become one of the new key words for the twenty-first century. He predicts that *"performance will be to the twentieth and twenty-first centuries what discipline was to the eighteenth and nineteenth, that is, an onto-historical formation of power and knowledge."*[1]

Interrelated performance platforms—the organizational, cultural, and technological—"form an immense performance site," he argues, "one that potentially encompasses the spheres of human labor and leisure activities and the behaviors of all industrially and electronically produced technologies."[2]

..

A look at scenarios and simulation point to some ways in which performance practices reactivate the past, rehearse the future, and produce a new "real."

Scenarios frame the setup and plotline within which simulation occurs.

Scenarios

A scenario—a plot framework or outline or description of what could happen—depends on *as-ifs* and *what-ifs*. Scenarios involving reenactment and simulation have been around for a very long time: the theatres in ancient Greece staged terrifying spectacles that, according to Aristotle, show things or

6.2 Virtual Iraq. JoAnn Difede, the VR therapist and director of the Program for Anxiety and Traumatic Stress Studies at Weill Cornell. Photo: Diana Taylor

events that "in themselves we view with pain [but] we delight to contemplate when reproduced with minute fidelity."[3] What we now call total-immersion scenarios have nothing on the Aztecs, who would abstain from sleeping, eating, and sex for days to enter into the appropriate alternate reality necessary to interact with their gods. But technologies of course alter the ways in which people experience and enact the *now*.

"Scenario" is a term originally used in theatre and theatre studies. Commedia dell' arte players used to follow a scenario—"an outline of entrances, exits, and action describing the plot of a play that was literally pinned to the back of the scenery."[4] Within these established parameters, actors played on the broad range of audience assumptions and expectations. Would the boy get to marry the girl, or would Pantaleon (the greedy old man) get in the way? Improvisations embellishing the general plotline allowed for variations and surprises. Contemporary events could easily be folded into the plot, and actors readily adapted to audience response. While the actors tested the limits of the scenario, suggesting alternative possibilities and outcomes, at the end of the play they returned to the conventional endings and assumed worldview. The boy would marry the girl, not another boy or the old man. Only in their playful improvisations, role reversals, impersonations, and misidentifications could players outstrip the reigning conventions.

The usefulness of the term far outreaches its sixteenth-century origins.

Scenarios, as portable, flexible frameworks for thinking and doing, have become privileged sites for modeling a wide range of practices. Pilots learn to fly airplanes in simulated cockpits. Fire drills teach people to evacuate buildings in an orderly manner. Language instructors encourage students to pretend they're sitting in a restaurant abroad ordering a meal or getting directions to the ever-elusive bathroom. The military uses reenactments and simulations to prepare their soldiers for combat.

All sorts of theme parks have sprung up offering extreme immersion and simulations for a paying audience. In Mexico, an indigenous community of the Hñähñú in Hidalgo organizes a grueling border crossing or *caminata* (walk), a simulation in which participants are fully immersed in the hardships (though not the dangers) of undocumented migration.[5] "'We wanted to have a type of tourism that really raised people's understanding,' says founder Alfonso Martínez, who dresses in a ski mask and goes by the name Poncho. 'So we decided to turn the painful experience all of us here have gone through into a kind of game that teaches something to our fellow Mexicans.'"[6] Thus border-crossing tourism uses scenarios and simulation to give people a better sense of the actual ongoing violence while profiting from those who pay for controlled risk-taking activities. As pedagogies of compassion, the walks encourage participants to understand what the "real" immigrants go through by walking in their moccasins or (in this case) sneakers.

The gap between rehearsing and doing becomes increasingly blurred as hypothetical scenarios take on "real"-life implications and effects.

Scenarios prompt the need and desire for embodiment, even if that embodiment is simulated or virtual. Unlike narrative, the plot needs to be acted out rather than told or described. Experiencing, once again, becomes a privileged way of knowing. But experience can no longer be limited to living bodies understood as pulsing biological organisms.

Embodiment, understood as the politics, awareness, and strategies of living in one's body, can be distanced from the physical body.

Digital platforms create their own experiential environments, allowing us to work, interact, and experience on multiples levels simultaneously. Architects can convey what a building or installation will look like by positioning visitors inside and outside 3D simulations. We can be here and there, present in various physical, simulated, and virtual environments. We are or have avatars in virtual environments. We have data doubles, our very own powerful digital other composed of bits and pieces of information. "People are broken down into a series of discrete informational flows which are stabilized and captured according to pre-established classified criteria. They are then transported to centralized locations to be reassembled and combined in ways that serve institutional agendas," write Richard Ericson and Kevin Haggerty.[7] If Jacques Lacan

theorized that human beings had an existential crisis by visualizing themselves whole in the mirror and yet experiencing their bodies as fragmented (because they can only see parts of them), the digital takes the questions of fragmentation and altered subjectivities to unexamined lengths.[8]

While scenarios allow for a continuity of cultural myths and assumptions, they usually work through reactivation rather than duplication. As opposed to a copy, the scenario constitutes a once-againness.[9] In the United States, the frontier scenario of the Wild West continues to animate films, cigarette ads, and political invasions. George W. Bush's appeal to

6.3 Diana Taylor in simulated environment, 2012, Santiago de Chile.
Photo: Rodrigo Tisi

old "Wanted Dead or Alive" posters put the Iraq conflict into the language of popular culture. Stephen Colbert rehearsed various apocalyptic end-of-all-that-we-love scenarios in his "Doomsday Bunkers" segments on *The Colbert Report*—a humorous response to Fox News's fear-mongering predictions.[10]

Though not predictive in function, scenarios tempt participants to extrapolate that what is determines what *will be*. Participants can play out the multiple variables in search for "likely" outcomes. The more persuasive the scenarios put forth, the more likely participants buy into them as a viable way of making sense of the world. As in commedia dell'arte, scenario thinking often ends up affirming the conventional ending and the given worldview.

The limits of scenario thinking for military, business, and other goal-driven efforts are many. One can only prepare for things one already imagines, so scenarios tend to reinforce certain ways of envisioning conflict and resolution. Same-sex marriage, in the commedia dell'arte example, would have been unimaginable. The assumptions that underlie scenario thinking presuppose agreement, so participants are trapped in frameworks in which the assumptions are not themselves examined. Scenarios are only as good as the people involved in conceptualizing them and, as planners do not usually involve real opponents or rivals in their simulations, scenarios tend to play out the participants' fears and fantasies. There are too many variables to make any reasonable prediction. **Nonetheless, scenarios function as the framework within which thinking takes place. Neither inherently good nor bad,**

they can simultaneously prepare us for and/or blind us to what is going on. We might go so far as suggest that they are what's going on. They reveal cultural imaginaries, ways societies envision themselves, their conflicts, and possible dénouements.[11]

Scenarios are making their way back into cultural and performance studies theory in ways that exceed their earlier use. They allow theorists to put bodies back into the framework, shifting the focus from written narrative to embodied culture, from the discursive to the performatic. Actions and behaviors arising from the setup might be predictable, but they are, ultimately, flexible and open to change. Social actors may be assigned roles, yet the irreconcilable friction between the social actors and the roles allows for degrees of critical detachment and cultural agency.

Because scenarios say more about the "us" envisioning them than about the "other" they try to model, they are fundamental to the ways societies understand themselves. They make visible, yet again, what is already there—the ghosts, the images, the stereotypes that haunt our present and resuscitate and reactivate old dramas.

And because scenarios are about "us," we need to factor ourselves in the picture—as participants, spectators, or witnesses we need to "be there," part of the act of transfer. Thus the scenario precludes a certain kind of distancing and places spectators within its frame, implicating "us" in its ethics and politics.

Bad scenarios blind us—they're all about percepticide, or self-blinding. Good scenarios heighten our awareness and encourage us to act to change the plotline in positive ways.

Simulations

"Sirens. A suicide bombing. The victims are rushed to hospital. It's a race against time to save this man's life."

So begins one simulation exercise at MSR, the Israel Center for Medical Simulation, considered the most comprehensive simulation center on earth.[12] In the control room, behind a one-way mirror, a trainer at the computer sets up the scenario: a suicide bomber has blown himself up in a crowded marketplace. We hear the blast. Chaos ensues. In the training room, a team of Israeli soldiers struggles to save a victim's life.

SimMAN, a very expensive, high-tech simulation mannequin lies on the floor. He has been programmed to mimic a variety of physiologic changes as the team works on him. His leg has been blown off, he bleeds profusely, his blood pressure drops, his heart races, his breath runs shallow and rapid. A soldier tries to ease a tube down his trachea while another puts an IV in his arm. Another ties a tourniquet on the bleeding stump. It's the ABCs of managing acute trauma—maintain airway, breathing, and circulation. The scenario gets increasingly complicated—more sounds of distress and sirens drown out the soldiers' voices. The patient deteriorates. The tension in the sim room escalates. The exercise may be simulated, but the sol-

6.4 Terrorist attack simulation, MSR, Israel, 2009. Photo: Diana Taylor

6.5 Terrorist attack simulation, MSR, Israel, 2009. Photo: Diana Taylor

diers experience a very visceral response to the emergency—their stress levels rise, their adrenalin escalates.[13] Technicians monitor all the activities and videotape the exercise.

Afterward I visit SimMAN in the hospital. Should I hold his hand?

Meanwhile, the teams meet with the head trainer to observe the videos and comment on their responses to the crisis. The soldiers analyze their responses again and again to consider alternatives. Instead of the old medical mantra of the 1980s and '90s, "See one, do one, teach one," medical simulation insists on rehearsing the actions in an environment in which it is safe to make mistakes. The point: one should learn by rehearsing, NOT by doing.

The immersive scenario training aspires to "reproducible, standardized, and objective" embodied behaviors and practices reminiscent of more scientific practice.[14] **The logic of the repertoire, which allows for a broad range of transmissions from the highly trained movements of a dancer to the less conscious or formal gestures and behaviors associated with certain groups or generations, is being harnessed into uniformity and reproducibility.**

MSR trains all of the doctors, nurses, medical students, and army personnel in Israel. It equips vans to train medical providers in the Occupied Territories. MSR hires actors to play the roles of patients visiting the doctor's office, or a relative receiving bad news. That afternoon I had been invited to give a talk at the Department of Theatre at the University of Tel Aviv. During our discussion, I asked the faculty and students

if they knew who was one of the largest employers of actors in Israel. They thought of everything but this mammoth simulation center, which spends 11 percent of its operating budget on "simulated patients" or actors.[15]

One problem with simulation, as Sherry Turkle points out, is that it "demands immersion and immersion makes it hard to doubt simulation."[16] The virtual, Turkle concludes, "makes some things seem more real."[17] Thus, she notes, "doubting [simulation] is difficult even for experts, because doubting simulation starts to feel like doubting one's own senses."[18] Not only that: scenarios and simulation also dissuade us from examining the framework itself. What of the political circumstances and cultural fears that make these scenarios and simulations so urgent and compelling? Who is examining the assumptions and options that underpin them?

What if . . .

7

Artivists (Artist-Activists), or, What's to Be Done?

Artivists (artist-activists) use performance to intervene in political contexts, struggles, and debates. **Performance, for some, is the continuation of politics by other means.**

The artivists presented here actively summon the tools of performance to fight for political and economic change.

The four brief examples included in this section refocus some of the issues I've presented throughout: the role of the body in performance activism; the boundaries between art and activism;

evaluating the "efficacy" of performance; and the power of performances mediated through video and the Internet.

The escrache protests carried out by H.I.J.O.S. (children of the disappeared and political prisoners) are large group actions that directly called for "trials and punishment" in postdictatorship Argentina; the work of performance artist Regina José Galindo illustrates how an individual confronts regimes of genocide in her country (at times during her lunch hour); Fulana uses video to intervene in a culture of privatization and forgetfulness; and the Yes Men digital action against Monsanto in 2013 shows how artivism can take place in a "disembodied" online manner for an international audience of Internet users.

I. H.I.J.O.S: "If there is not justice, there is escrache"

In 1995, the children of Argentina's disappeared and political prisoners organized as H.I.J.O.S. Since then, they have pushed for "justice and punishment" for the military leaders and accomplices responsible for the disappearance, torture, and death of their parents during the military dictatorship that lasted from 1976 to 1983. The protests by H.I.J.O.S. are very different from the sorrowful, ritualized walks of the Mothers of Plaza de Mayo for several reasons. In 1977, when the Mothers started demanding information about their missing children, the dictatorship was in its early, most violent phase. The Mothers, wearing photos of their disappeared sons and daughters around their necks, claimed to simply be carrying out their appropriate roles as *mothers* in a masculinist society—looking for and after their children. They identified themselves as *mothers*

by wearing what they claimed were their children's diapers as headscarves. They made clear they were defenseless—many of the women were middle-aged and out of shape. They walked around Argentina's central square to remain visible and protect themselves from attack. They chose the frame (time and place) and the acts carefully. The military could hardly be seen massacring unarmed mothers in front of Argentina's presidential palace—especially if people were watching. Several of the founding Mothers of Plaza de Mayo were abducted and killed from one of their informal meeting places, and many more were constantly threatened.

In performance, context is all.

...

H.I.J.O.S, who started their activism after the fall of the dictatorship, were young, energetic, and free to move around the city and the country. Although they continue their activism, the situation has changed, and so have their tactics. Throughout their two decades of confronting human rights violators, they have been bolder in their actions and in their appropriation of space. They directly confront those who carried out human rights violations, and oblige them to relinquish their anonymity. In the early years, H.I.J.O.S choreographed striking carnivalesque escraches, acts of public shaming or outing.

...

The escraches, acts of public repudiation, are a type of guerrilla performance.

H.I.J.O.S. seek to undermine the myth that everything is going well in the country, that there is no reason to think about the past.

The military and their accomplices had been keeping a low profile to evade retribution since the end of the dictatorship. The escraches vary in size and intention. Some members of H.I.J.O.S. might show up at perpetrator's trial and accuse him. Or a large group might arrive at a clandestine torture center or go to the house or office of a physician who participated in genocide. The objective of the escraches has been to generate public awareness about the unpunished crimes, those who committed them, and the organizations that supported them, many of which continue to operate today.

The escraches are deeply theatrical. At times hundreds of young people (in their twenties when the organization started) danced and sang down the streets to blaring music. With loudspeakers, they announced to their neighbors that they were living next to a clandestine torture center, or to a perpetrator. With the help of artivists like the Grupo Arte Callejero (a group of predominantly women street artists), H.I.J.O.S. intervened in the social arena by creating street signs ("500 M to a torture center") or reminding the population of the histories of the dictatorships throughout the Americas. They created small city maps that listed the names and addresses of perpetrators.

A month before each escrache, the members of H.I.J.O.S. would start preparing the residents of the neighborhood in which the target lived or worked. They filled the streets with photographs and information about the criminal.

7.1 Street signs with the photo of a perpetrator of torture, 2010. Photo courtesy of Grupo de Arte

Did you know that your neighbor is a torturer?

The torturers, hiding from H.I.J.O.S., modified their appearances, reinvented their identities, and burned their own photos. Some perpetrators remained hidden in plain sight. When they were not able to get ahold of recent photos, H.I.J.O.S. stalked their subjects. But instead of disappearing their targets, as the military did their parents, they made them appear. H.I.J.O.S. photographed and circulated the faces of the perpetrators. This example shows that H.I.J.O.S. has borrowed strategies used by the military leaders, although the differences are essential. The tactics employed by H.I.J.O.S. served to identify those responsible for flagrant violations of human rights. The "outing," although hard for the torturers to handle, did not put their lives in danger. H.I.J.O.S, like the Mothers of the Plaza, was making a call for institutional justice, not parajudicial revenge.

Escraches remind torturers that H.I.J.O.S. know who they are.

H.I.J.O.S. say they enjoy the release of energy that characterizes their youthful style of activism. Their actions stem from an affective place of joy rather than sorrow and trauma. At the

beginnings of the 2000s, the escraches became international. Children of the disappeared, of political prisoners, and exiled activists started working together throughout the Americas and even Europe. If the CIA created an international terror network with their Condor Plan, and trained torturers in the U.S. School of the Americas, H.I.J.O.S. created their own international network to fight for justice and human rights.

The short-term and long-term effects of these performances are difficult to measure. Over four hundred torturers have been brought to trial and are now serving life sentences. Did the activism by Mothers and H.I.J.O.S. make that happen? It's hard to prove, although we would probably be correct in saying that justice would *not* have been done had the groups not persisted. Now that the call for "justice and punishment" has been heeded, H.I.J.O.S. no longer carry out their large escraches. They too are older now. But they continue to investigate the whereabouts of perpetrators and "out" them. "¡A DONDE VAYAN LOS IREMOS A BUSCAR!" says a January 2014 Facebook page entry by H.I.J.O.S. showing a photograph of a smiling man sunning himself on a beach in Uruguay, holding a pineapple drink. He is accused of having killed twenty-three Italians. The search (for justice) continues.

As the Mothers and H.I.J.O.S. have made evident, **the search for justice is a long durational performance. Although the tactics and circumstances change over time, it's the endurance and perseverance that prove efficacious. The**

7.2 Photo courtesy of H.I.J.O.S. and Grupo de Arte Callejero, 2000

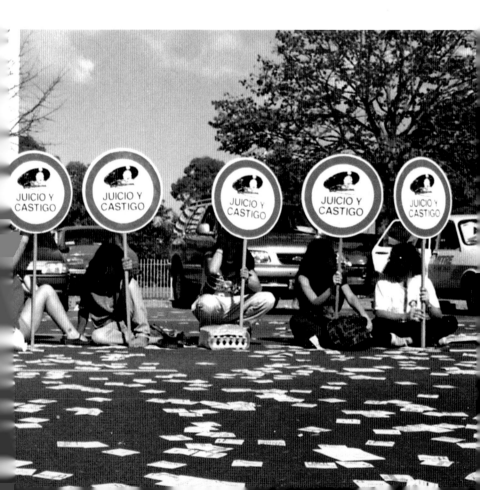

struggle for justice might take a lifetime. But they also make clear that we cannot leave it up to the relatives of the disappeared to protest against human rights violations. While most of us are not the victims or the survivors or the perpetrators of these crimes, we still participate in criminal politics. Our governments coordinate systems of repression, and our tax dollars pay for them. With all of the atrocities that continue to be committed throughout the Americas (not even considering those happening further away), these artivists help us to remember that we (all) live in proximity to political violence.

II. Regina José Galindo

Whenever people lament that "there's nothing we can do" about some awful situation or other, I ask them to go tell that to Regina José Galindo.

Regina José Galindo is an interesting performer for many reasons: (1) although she uses her art to call attention to the violence that surrounds us, she does not consider herself an activist; (2) the focus of her work changes depending on where she is working. If she has been invited to perform in the United States or Germany, as we will see, her work investigates violence that exists there, whether now or in the past; (3) she doesn't believe that her work changes anything, but she knows that she must continue doing it. Her art challenges those who say that artists should limit themselves to their own context (for ethical reasons), that they should avoid the political to

maintain their aesthetic integrity, and that they need to see results from their work in order to remain committed to it. While these aspects of her work might rise from and engage the art world and activist circles in various ways, she combines them in ways that push and, I would argue, transcend and blur the boundaries of both.

Since 1999 Galindo has created dozens of performance works. Like many of the artists we have considered, she frequently uses her own body as the zone of confrontation between violent social forces. She grew up in Guatemala during a period she describes as follows:

> Guatemala has experienced 36 years of extremely bloody war. The genocide left 200,000 dead. The military fought against the insurgents and classified the indigenous people as "internal enemies" accused of sympathizing with the guerrillas and persecuted them during the most brutal periods. The national government implemented a scorched earth policy, a plan to take the indigenous lands under the pretext that they were enemies of the State. This was common practice and one of the defining features of the Guatemalan armed conflict. Soldiers from the army and civil defense forces would arrive at indigenous communities and destroy everything people needed for survival: food, clothes, their harvest, homes, animals and so on. They burnt everything. They raped. Tortured. Murdered. Many bodies were buried in mass pits that today contribute to the long list of evidence that confirms the facts.[1]

No matter where Galindo performs, this background informs

her approach to her work. She recounts being at work in an office when she heard that Efraín Ríos Montt, the military dictator responsible for the genocides during 1982–83, was running for president of Guatemala in the 2003 democratic elections. She says she went home, locked herself in her room, screamed, and kicked her legs. On a lunch break a few days later, she took a basin full of human blood and left footprints from the Constitutional Court to the National Palace in Guatemala City. This piece is called *Who Can Erase the Traces?* (2003). Afterward, Galindo washed her feet and went back to work.

The Regina Galindo lunch break.

..

Galindo confesses that her rage animates her.[2] The necessity to express herself at all costs is also personal, the result of her own personal experiences:

> *Without the scenes of violence that I witnessed as a child, perhaps I would be different . . .*
>
> *Without the earthquakes, the scares, the bombs . . .*
>
> *Without the gun shot in my daughter's window, without the damn daily gunshots . . . without the desire to leave, the desire to stay . . .*
>
> *Without the life I have chosen, or the life that chose me. Maybe I would do something else. Without that which I have seen, I have lived, I have heard, I have learned, maybe everything would be different. But I have lived what I have lived. I have*

played the cards I was dealt. I was born where I was born, I have done what I have done, and now I do what I do.

And what I do is simple. I rethink, I reinterpret. I create from something already created. I transform my own experiences and those of others into new images, new actions, where the order of the elements does affect the product. An art product, yes . . . but a product nonetheless.[3]

Galindo's physical appearance—she is a very petite woman—accentuates her determination and bravery. Her performances are shocking, especially to the extent to which she makes herself vulnerable. In one work, she places her naked body in a clear, plastic garbage bag to be thrown out in the city dump (*No perdemos nada con nacer / We Lose Nothing by Being Born*, 2000). In another, she shaves her body from head to toe and walks naked through the streets of Venice (*Piel / Skin*, 2001). She injects herself with Valium (2000), buys human blood for various works (*¿Quién puede borrar las huellas? / Who Can Erase the Traces?*, 2003, and *El peso de la sangre / The Weight of Blood*, 2004). She sells her blood in another (*Crisis sangre / Blood Crisis*, 2009). She submits her body to blows, surgeries (*Himenoplastia / Hymenoplasty*, 2004—a process in which a surgeon "restores" the hymen), mutilation (*Perra / Bitch*, 2005, in which she carves the word *perra* into her leg), and sexual harassment (*Mientras ellos siguen libres / While They Remain Free*, 2007), among other atrocious acts, to bring visibility to the constant and invisibilized acts of violence against women.

But Galindo also understands the acts of violence as interconnected. The CIA supported Ríos Montt and is also indirectly responsible for the genocide. The people who fled the violence in Guatemala and sought asylum in the United States have ended up detained, deported, or dead. When she was invited to be an artist-in-residence at Artpace in San Antonio, Texas, she accepted, and for her performance, Artpace rented her one of the small, one-room detention cells used to incarcerate entire families of undocumented immigrants.

In *America's Family Prison* (2008), she remained locked in the cell with her husband and infant daughter for twenty-four hours. During the performance, many spectators argued that she was an irresponsible mother for keeping her daughter in such conditions, not thinking, of course, of the thousands of families that are locked up for months or years without inciting any public protest. In *Plomo / Lead* (2006), Galindo used the $5,000 stipend she has received from a U.S. foundation to pay a Dominican ex–military officer to teach her to use different types of military weapons—pistols, revolvers, rifles, and shotguns. The project underlined the fact that the money the United States sends to Guatemala is to train the military and acquire arms. This performance, known only through photos and video (that is to say, its documentation), refers to practices that are also hard to see directly, and are visible, if at all, through acts of documentation. The performance, understood in its larger framework, exposes the traffic of weapons as a performance of power, militarism, and neo-imperialism in the Americas.

The critique implicit in Galindo's work is not limited to the relationship between the United States and Guatemala. In preparation for a performance in Germany in 2010, she paid a Guatemalan dentist to hollow out part of her molars and insert gold fillings. In Germany, her performance consisted of contracting a dentist to take out the gold in an art gallery. This work not only evoked the practices of the Nazis with the Jews, but also pointed toward the participation of professionals (dentists, doctors, and so on) in various questionable political operations. The complicity of the medical profession in criminal politics has been an ongoing theme in her work. It also illustrates that while rich nations extract natural resources from poor countries, the poor countries themselves often collaborate in the violence for short-term gain.

A newer intervention based on this act exhibited the gold crowns beautifully displayed in a gallery—one more instantiation of cultural and individual dispossession taken out of its place and context to show as art.

Earth (2013)

"How did they kill people?" The prosecutor asked.

"First, they would tell the machine operator to dig a pit. Then trucks full of people parked in front of the Pine, and one by one the people came forward. They didn't shoot them. Often they would pierce them with bayonets. They would rip their

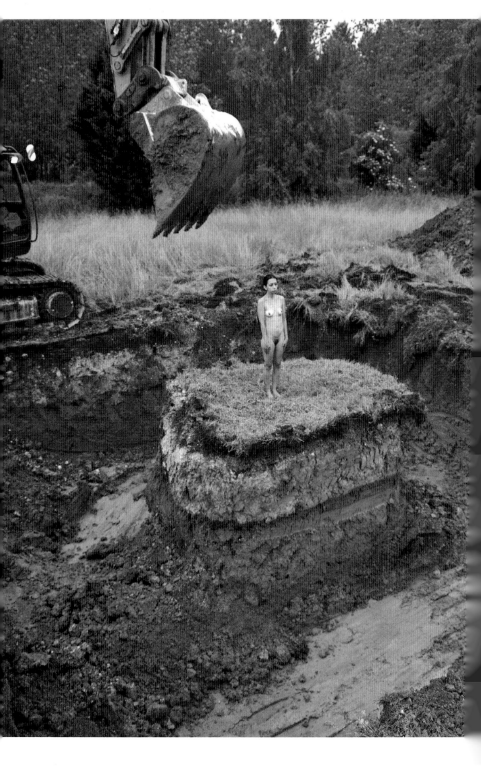

*chests apart with bayonets and take them to the pit. When
the pit was full, the metal shovel would drop on the bodies."*

—*Testimony given during the trial against General Efraín
Ríos Montt and Mauricio Rodríguez Sánchez*

..

Galindo's performance *Earth* took place in France in 2013.
There were three other people there and two video cameras.
In the video we see her, a diminutive woman, standing naked
and defenseless as a bulldozer methodically digs a hole in the
earth all the way around her. Again and again, the giant claw
pushes down, grabs massive mouthfuls of earth, gyrates, and
throws them to the side, gyrates wildly back, closer and closer
to her small body. The hole gets deeper. The machine grinds,
and buzzes, and crashes just behind, in front, or to the sides
of her. She stands still, her hair in a braid down her thin back,
her hands resting on her thighs. There is nothing erotic about
her. Her body transmits not the promise of pleasure but signs
of wounding. What's that on her right leg? And she seems to
have a scar right above her pubis. The only thing that moves
is the enormous bulldozer. Even the camera moves minimally,
the close-up fades into a wide-angle shot and back again. She
is increasingly isolated, and soon she's standing on an island of
earth. The pit is many meters deep, and it's clear that she can
never get out. The live performance lasts an hour and a half;
the video of the performance runs about thirty-five minutes.

7.3 Regina Galindo's *Tierra*. Commissioned and produced by
Estudio Orta. Les Moulins Francia. Photo: Bertrand

How can one convey the asymmetrical power relations more directly or more simply? "Don't you see?" she might be asking us. Or better, where are we, the spectators, the witnesses to this atrocity? No one, it seems, is there to see. Nothing apparently can be done to evade the devastation.

But why France? Part of the answer seems random or pragmatic—she was offered an artist's residency that offered her the land and the financial support to carry forward a project of this size and expense. Timing was key—Galindo felt the urgency of responding to the recent testimony from the trial. Nevertheless, Galindo is never random. Again, she connects the links in the violent chain. France developed the counterinsurgency strategies in Indochine and Algeria that the United States imported to add to its Cold War arsenal. The word "disappearance" entered our lexicon in 1954 when a CIA-backed coup overthrew Jacobo Arbenz, the progressive president of Guatemala who tried to rein in the United Fruit Company and legislate land reform. During most of the thirty-six-year civil war, the United States supported the Guatemalan military and trained its officers (including Ríos Montt) in the infamous School of the Americas, specializing in torture and disappearance. The current president, Pérez Molina, is also a military officer trained in the School of the Americas. Guatemala's transition from dictatorship, as in much of Latin America, was not a transition to democracy but to a particular savage brand of neoliberalism. After the extermination of two hundred thousands Mayans, the dispossession of their lands, and the des-

perate conditions that force others to flee (now to the United States), their traditional lands are free for the taking. Canadian mining companies, backed by French capital, now extract resources from that earth, bucketful by bucketful.

...

Does Galindo tell us all this? No. She stands still. "Stillness," as Nadia Seremetakis puts it, "is the moment when the buried, the discarded, and the forgotten escape to the social surface of awareness."[4] Her performance of stillness brings these histories to the surface, subtly revealing the networks and practices that create and sustain this ongoing crisis. Yet the performance is known only through its documentation, the photographs, and the video. Unlike photo-performances by Guillermo Gómez-Peña, which function "like heightened excerpts of a live performance that never took place,'"[5] Galindo's reveal practices, such as disappearances, that take place, certainly, but only at the margins of the public gaze. Spectators are thus denied direct access to them. Is this, then, an archival performance? Does it reveal a specific transaction or event? Is it a testimony to a crime? Or, rather, can we understand *Earth* only in its larger framework, as the work of an artist who exposes the traffic of weapons, drugs, and people, as well as the disappearances and disposability of populations that exceed the archive as an ongoing, moneymaking, transnational event?

The lucidity and explanatory power of each piece is impressive: the earth, her vulnerable naked body, the encroaching and expanding threat as the pit widens in front of her, the nonhu-

man presentation of the killing machine. The image needs to be immediately graspable without being obvious or clichéd. Galindo emphasizes the formal aspects of her work, perhaps in response to the chaos within which she lives, to the violence that has surrounded her all of her life. All she can control is what she herself can create. Art provides her a means of intervention into the political (which she cannot control) by using her body, her imagination, her training, self-discipline, and, now, her name recognition.[6] For Galindo, the difference between artists and activists is that activists protest specific issues, and they evaluate the efficacy of the act by whether or not it can change the outcome of the cause. As an artist, she claims the right to reflect on these issues in a more personal, idiosyncratic manner. She has no illusions that she can change the political situation, but she does everything in her power to make the situation known in the most forceful way possible.

I include Regina José Galindo in the this chapter on **ARTIVISTS** in part to further complicate the differentiation between the two terms—artist and activist—that often become intertwined. I do not believe there is a purely political response to a political situation; we all respond in a way that is social. We are part of everything that surrounds us, even if we close our eyes to that reality. When Guatemalan author Francisco Goldman asked Galindo in an interview what their poor country had done to deserve so much tragedy, she responded:

> *You ask me what Guatemala has done to deserve all this?*
> *Maybe the more appropriate questions would be: What have*

we not *done? Why have we been so fearful and tolerated so*
much fear? Why have we not woken up and reacted? When
are we going to stop being so submissive?[7]

Galindo wants to avoid the romanticism of those who struggle
for social justice; she does not see struggle as a heroic or ro-
mantic activity. Unlike activists, she does not believe that it's
crucial for her to change the system of power. That expectation
might paralyze her, and make her too resign herself to the at-
titude that nothing can be done. In 2008, she was invited to
participate in *Horror vacui,* a group show of young Guatemalan
artists around the theme of "denunciation." How had they in-
tervened in a society marked by criminal violence? Galindo's
contribution was to pay an intelligence expert who had worked
for the security forces during the dirty war to investigate the
artists participating in the show, just as he had during the dic-
tatorship. He prepared a dossier about each artist containing
personal data (address, names of family members, daily rou-
tine, bank transactions, everything). The intelligence expert
came to the show and exhibited his findings: all those artists
who considered themselves "denunciators" had not, in fact, de-
cried anything that was not already well known. He concluded
that they posed no threat to the army or the government and
were, rather, more like children at play. She presented this as
the performance *Infiltrado / Infiltrated.*

So, what is the political force and efficacy of performance?
Does her standing naked by the open pit communicate any-
thing that was not well known before? Maybe, says Galindo,

it is sufficient for the performance to impel the spectators to reflect on the issue. For her, this modest goal is sufficient.

The work that Galindo performs is necessary. To do something, for her, is an act of necessity. For too many people, to do nothing is preferable: there are many reasons for not acting. Some say that nothing is going to change the world, or even the immediate situation. Others create other rationales: they are not from this country, or from this community. How does someone dare involve herself in the business of other people? Is that ethical? The asymmetries of power leave others feeling impotent. Who is able to effectively confront military might? Or religious domination? But for people who feel the need to intervene (and not only to speak about intervening), these excuses don't hold up.

The question is not whether anything can be done but what can be done and how to do it in a way that is effective, responsible, and ethical.

Protest and outrage are vital social responses to awful situations. If public response had no power, why would governments bother to criminalize protests and demonstrations?

The ethical considerations of performance are essential. An artist/activist may cut, mutilate, or flagellate herself, but she cannot do it to another person without his consent. She can

perform a work that risks her own employment or arrest, but she cannot put others at risk without their permission. She can act, but she cannot hide her face—that is to say, the artivist must take responsibility for the acts she initiates. Performances, as these artivists suggest, are not representations or imitations of certain actions. They are not about falsifications of something REAL. They are ACTIONS, interventions in the world. These performances have consequences, even if they do not always have the power or efficacy the artist wishes.

III. Fulana

The last two examples of artivist works focus on the role of human bodies (collective in the case of H.I.J.O.S. and individual with Regina José Galindo) in confronting regimes of power. Here I will look at interventions made by Fulana, a Latina performance and media collective from New York City founded in 2000 by Marlène Ramírez-Cancio, Lisandra Ramos-Grullón, Andrea Thome, and Cristina Ibarra to address the questions that Galindo also asks: what can people do about awful situations?

Amnezac (2006), the one-minute satirical video performance piece by Fulana, plays like a commercial.[8] A distressed, middle-class Latina woman stands overwhelmed by the bills on her beautiful wood kitchen countertop.

Troubling images of the U.S. invasion of Iraq and torture at Abu Ghraib disturb her. The contrapuntal images (such as Iraq/Panama) suggest that the current violence reminds her

amnezac ©

amnescilin/atrocitate oblivium
20mg tablets

The Most Powerful Anti-Historiamine on the Market™

7.4 Rachelle Mendez in Fulana's *Amnezac*. Video still courtesy of the artists

7.5 Fulana, *Amnezac: The Most Powerful Anti-Historiamine on the Market*

of U.S. violence directed at Latin America. ("Does the Iraq war remind you of U.S. invasions of Latin American countries, including your own?" the voice-over asks.) Images of protestors who look very much like her defiantly stand up to the armed forces. Some young people are being brutally dragged away. She struggles heroically to keep the troubling images out of her mind—she tries not to see. The voice-over suggests that she might need to take something to control the anxiety that is interfering with her "patriotic duty" to shop and pay taxes. Citizens, after all, are powerless. They cannot change "world events." Evasion, not activism, is her civic duty. The kitchen, in this age of privatization, is her arena of struggle or, better, retreat. But images of Latin American dictators, Abu Ghraib, and Halliburton refuse to stay repressed. The style of politics has changed—the authoritarian military leaders parading with the armed forces have gone out of fashion. Bad things (like Abu Ghraib) get blamed on deviant low-level soldiers. Faceless corporations, like Halliburton, call the shots. Still, even with the new look of criminal politics, brutal images, like traumatic flashbacks, intrude on her daily life and cause distress. The diagnosis: "You may be suffering from Historical Memoritis." "-Itis" denotes inflammation; historical memory inflames and burns. It distorts things (violence, corruption) out of proportion. It makes the person overly sensitive. Recalling past events is a "cognitive disorder." Better not to see, not to connect the dots. Block that memory! People can be agents of their own well-being, the ad suggests: "Don't let Iraq hold you back!" The imperative to live a worry-free, even happy, life trumps social responsibility, depicted as a very real physical and psychic liability. Clearly suffering, she stoops over, scowls. The solution

is easy—"*Amnezac: The Most Powerful Anti-Historiamine on the Market*." Its Latin name says it all: amnescilin/atrocitate oblivium—induced amnesia erases memories of atrocity. Antihistory, antimemory, percepticide is the "American" way. Having taken her pills, she resumes her gleeful shopping, though the ad warns that side effects might include "mindless consumerism, acute xenophobia, severe greed, and blindness to global injustice."

..

This brilliant satire points to profound truths—in the United States, political, economic, and social issues are disavowed as "events" as "politics" and displaced onto individual bodies where they are lived as symptoms. The displacement disappears the political scenario of U.S. conquest and exploitation that gets reenacted again and again (Latin America, the Middle East, and so on) and blames her, the individual—her distress is her problem. Agency moves from the polis to the private, from the citizen to the consumer. It is her responsibility to feel better, not to change the events of which she is a part. Privatization as part of neoliberalism can lead to willful ignorance, the active not-knowing that reminds us that "idiot" is linked etymologically to a "private person."[9] The transition from the political body to individual body passes through the circuit of pathology and medicalization. The images that *Amnezac* brings together (the United Fruit Company next to Halliburton) are exactly the ones that big business, big pharma, and the military industrial complex try so hard to disappear. The layers upon layers of historical colonial practices are flattened out—her hands flatten the bills against the surface of her counter-

top as if she were trying to smother memory itself. Big pharma is there to help. No more dark thoughts and memories—it's all carefree domesticity for her. The economy, conjured up by the shopping bags, elides the costs of the U.S. invasion of Iraq, which do not include social externalities—PTSD, anxiety disorders, trauma, and the like. The American flag leads soldiers into battle while it allows us—the patriotic "you" invoked by the voice-over—to forget Iraq and go out shopping. For her, the battle is fought in and around "things"—the shoes and other material objects that prompt thing theorist Bill Brown to refer to "the materialization of politics." [10]

Amnezac points to the ways in which not only things and resources are unequally distributed throughout the Americas but so too the ways in which pain, suffering, and trauma are incorporated and lived as well. The violence is unequally distributed. The larger sociopolitical level also shows evidence of displacement—some countries have the problem (a voracious war engine, drug addiction) and others have the symptoms. Latin Americans, as H.I.J.O.S. and Galindo remind us, suffer the effects of U.S.-led invasions, extractions, and other imperialist policies. Amnezac emphasizes that the imperial engine is also about the creation and satisfaction of desire—bad things happen in other countries because we want the good things that shopping offers—the nice kitchen, cheap clothes, the shoes. Shopping therapy and pharmaceuticals serve several functions—they placate her and keep the economy going. They nudge war out of the picture. Yet her patriotic duty, shopping and paying taxes, lubricates the war machine that

targets people just like her. The money she spends alleviating the traumatic affect goes to support the trauma-producing violence (the atrocity) in the first place. What looks like a simple narrative arc—from anxiety to well-being—is actually a very vicious circle.

Again, as with the other examples, here too context is everything. Fulana's video as "delivery system" for the critique parodies the mass media as the delivery system that creates consumers and lulls them into submission. The television ad, part of the larger military-industrial-entertainment-pharmaceutical system, transforms the political into the purely individual, and models desirable behaviors for the general population. The video performance, thus, provides the perfect form for the artistic intervention.

IV. Yes Men

Andy Bichlbaum and Mike Bonanno (Jacques Servin and Igor Vamos, respectively) are the Yes Men, artivists who parody powerful corporate leaders and spokesmen through what they call *identity correction*, that is, "impersonating big-time criminals in order to publicly humiliate them, and otherwise giving journalists excuses to cover important issues."[11] Since 1999, they have been getting into all sorts of trouble, impersonating a spokesperson from Dow Chemical on the BBC NewsHour, another from Halliburton, yet another claiming to be from the U.S. Chamber of Commerce, and so on. During these impersonations, the two often build false hope that companies will finally do the right thing (recompense the victims of the

Bhopal disaster in Dow's case) or that the U.S. Chamber of Commerce would support environmental legislation.[12] When the organizations rushed to declare that in fact the announcements were a hoax, that they had no intention of doing the right thing, they fell into what is known as a "decision dilemma"—the "damned if you do and damned if you don't" gold standard for activists. The "target" looks ridiculous no matter what it does. The Chamber of Commerce was so incensed at the Yes Men[13] that they sued them. As the lawsuit dragged on and on, the Chamber finally gave up its suit. The Yes Men then sued them back, for dropping the suit. Dow was too savvy to fall for the suing trick, but they did send "spies," as Servin calls them, to keep track of the Yes Men's doings.

..

Servin (as Bichlbaum) writes in *Beautiful Trouble*:

> When trying to understand how a machine works, it helps to expose its guts. The same can be said of powerful people or corporations who enrich themselves at the expense of everyone else. By catching powerful entities off-guard—say, by speaking on their behalf about wonderful things they should do (but in reality won't)—you can momentarily expose them to public scrutiny. In this way, everyone gets to see how they work and can figure out how better to oppose them.
>
> This is identity correction: exposing an entity's inner workings to public scrutiny. To practice it, find a target—some entity running amok—and think of something true they could say but never would—something that's also lots of fun. What you say can either be something your target would say if its

PR department went absent or berserk (modest proposal), or things they would say if by some miracle they decided to do the right thing (honest proposal). Instead of speaking truth to power, as the Quakers suggest, you assume the mask of power to speak a little lie that tells a greater truth.[14]

"Sometimes it takes a lie to expose the truth," the Yes Men say.

Since 2011, the Yes Lab has been at the Hemispheric Institute and Jacques Servin has been a visiting faculty member at New York University. As part of Hemi's summer course, Art & Resistance, held in San Cristobal de las Casas, Chiapas, Mexico, in 2010, 2011, and 2013, the group has normally staged street protests, directed by Jesusa Rodríguez, who coteaches the course. Twice we have chosen to orchestrate a street action against Monsanto for planting genetically modified corn on an experimental basis in Mexico, corn's country of origin. The GMOs, most activists agree, impoverish local farmers and pose health dangers. They also threaten the diversity of the crop, the environment, and the cultures that developed in connection to agricultural practices. Mesoamericans have been developing corn for the past ten thousand years. They think of themselves, by extension, as the "people of corn." Hundreds of countries have condemned planting GM crops, and understand them as especially threatening to countries of origin.[15]

In 2013, as usual, the thirty-five participants from throughout the Americas (and beyond) staged a fabulous street performance of the People of Corn combating big bad Monsanto. Monsanto wore a tuxedo, a top hat, and a pig's face. On his

arm, a glorious drag performer dressed in a variation of the national flag, pranced around as the adoring Motherland, eager to pick up the pennies that fell from Monsanto's wallet. The People of Corn, covered in beautiful body-paint, sang and danced to the God of Corn. The performance involved spectators and ended with a public volleyball game in front of the town's main cathedral. A young Mayan girl actually threw the ball that defeated the Monsanto team, to great applause and shouts of joy.

But this year (2013) something else happened. Jacques Servin had joined us for the course, and I along with a few participants and some people from town decided to carry our intervention into the virtual realm. This had nothing to do with the course, but we were there in Chiapas, drinking beer with Jacques Servin and, well, it seemed like a good idea at the time.

In a few days we had prepared our digital action. In true Yes Men fashion, we launched a fake website claiming to be Monsanto's. Monsanto had requested permission from Sagarpa, the secretariat of agriculture in Mexico, to plant GM corn commercially. The answer to the request was expected at any moment. Our press release, on the fake Monsanto website, announced that the request had been granted and thanked all those people in government for their invaluable help in moving Monsanto's interests along to fruition. We, of course, thanked them by name and cc'ed them in our communiqué.

MONSANTO

Who We Are Products News & Views Improving Agriculture

News & Views

Monsanto in the News

Newsroom
News Releases
Codex Mexico
Myths and Facts

Issues & Answers

Executive Speeches

News Releases

Mexico Grants Monsanto Approval To Plant Large-Scale GM Corn Fields

Company Addresses Opponents' Concerns With Museum, Seed Vault Initiatives

MEXICO CITY (Aug 14, 2013): The planting of genetically modified (GM) corn fields on a large commercial scale has been approved by the Mexican Secretariat of Agriculture (SAGARPA). The permit allows the planting of 250,000 hectares of three varieties of GM corn (MON-89034-3, MON-00603-6 and MON-88017-3) in the states of Chihuahua, Coahuila and Durango. This is the first time GM corn will have been planted on a large commercial scale in Mexico.

"We are very grateful to the Mexican government for the precautionary measures it has instituted and the seriousness with which it enforces them," said Manuel Bravo, President and Director of Monsanto Mexico. "We wish to thank those responsible for this decision, in particular the President of the Republic, Lic. Enrique Peña Nieto; Enrique Martínez y Martínez of SAGARPA; as well as all the government institutions that are part of the Intersecretarial Commission on the Biosecurity of Genetically Modified Organisms (CIBIOGEM)." (Refer to full list below.)

"Profound steps forward are always accompanied by concerns," noted Gerald A. Steiner, Monsanto's Vice President for Sustainability and Corporate Affairs. "This is natural, and it is natural that we would make every effort to address those concerns. We are proud of our cultural and scientific initiatives in this respect."

One such initiative is the National Seed Vault (Bóveda Nacional de Semillas, BNS), whose charter is to safeguard the 246 native Mexican corn strains from ever being fully lost. The BNS will also include a Maize Varieties Tasting Center (Centro de Degustación de Variedades de Maíz, CDVM), where people can sample many varieties of native corn, as well as 30 varieties of GM corn. The BNS will also make native varieties available to environmental education and preservation groups in Mexico and elsewhere, as well as to eco-gastronomy chefs worldwide.

"The BNS is a great solution to concerns about the contamination of native strains," said a statement by the Mexican Association of Concerned Scientists, a group formed in 2011 in order to address concerns about the distribution of biotechnology in Mexico. "It guarantees that our rich agricultural patrimony will survive for all time."

Additionally, Monsanto is funding the Codex Mexico (Codice México), a digital archive preserving the vast wealth of Mexican culture for centuries to come.

"The Codex Mexico is a visionary initiative that will allow future generations of children to know far more about our lives today than we know of our pre-Columbian ancestors,'" noted forensic anthropologist Marcelo Rodríguez Gutiérrez. "Never again will the wealth of this region's culture be lost as social conditions change."

August 13 marks the traditional Mexican birthday of corn. "Monsanto is honored to inaugurate a revolutionary new era in the 4500-year history of Mexican corn," said Bravo. "Even as we preserve this rich history, we will be able to provide many farmers the opportunity to dramatically increase their industrial profitability."

7.6 Fake Monsanto website created by the Yes Lab.
Photo courtesy of YesLab.org

MEXICO CITY *(Aug 14, 2013): The planting of genetically modified (GM) corn fields on a large commercial scale has been approved by the Mexican Secretariat of Agriculture (SAGARPA). The permit allows the planting of 250,000 hectares of three varieties of GM corn (MON-89034-3, MON-00603-6 and MON-88017-3) in the states of Chihuahua, Coahuila and Durango. This is the first time GM corn will have been planted on a large commercial scale in Mexico.*[16]

The release went on to add that Monsanto, aware that critics would decry the threat to the diversity of corn in Mexico, contaminated or displaced by the GM crops, would enact certain measures. "One such initiative is the National Seed Vault (Bóveda Nacional de Semillas, BNS), whose charter is to safeguard the 246 native Mexican corn strains from ever being fully lost." The "fully" lost, we felt, was a nice touch.

Another initiative, we claimed, was the creation of the "Codex Mexico (Codice México), a digital archive preserving the vast wealth of Mexican culture for centuries to come. 'The Codex Mexico is a visionary initiative that will allow future generations of children to know far more about our lives today than we know of our pre-Columbian ancestors,' noted forensic anthropologist Marcelo Rodríguez Gutiérrez. 'Never again will the wealth of this region's culture be lost as social conditions change.'" The new conquest would be kinder and less devastating than the last.

Monsanto, faced with the decision dilemma of responding to or ignoring the prank, did not take long to respond. Within

twenty minutes they had us on the phone demanding that we take our hoax site down. They immediately released a disclaimer. Nothing in the last press release was true. We, as requested, then issued our own disclaimer, saying that nothing in the last press release was true, and that led to a wonderful general confusion. Given the widespread activism around the GMO issue, we were leaked an email that Monsanto had just sent to Sagarpa, apologizing for the confusion and promising to get things under control. Monsanto reiterated the need for confidentiality.

On September 13, 2013, Monsanto contacted the president of NYU to complain about the street and digital action. They wanted to know about the course, see the syllabus, and understand the relationship of the actions to NYU. They also wanted an apology from NYU.

This created a new drama, one that dominated our fall semester 2013 at NYU.

NYU questioned Servin and me. Phrases such as "code of ethics," "academic freedom," and "conflict of interest" came up. Apparently, our action had placed us on the wrong side of each.

We stressed that the digital action had nothing to do with NYU.

We had a few questions of our own.

What did Monsanto object to—the street action or the digital action?

How is impersonation on the street different from imperson-ation online?

How had our action harmed Monsanto? Really? (It was just play.)

Wouldn't it be great to organize a conference at NYU to discuss the limits of activism in and at the margins of institutional settings?

As for our purported violations we also had questions. Conflict of interest? Us? I asked our officer from NYU who had herself enjoyed an important position at Monsanto. Violation of an ethical code? Define ethics. Polluting the environment and harming humans? Monsanto had seemingly infinite resources and strategies to counter any evidence of wrongdoing against them. All we had, as professors, to shield us was academic free-dom.

After a few back-and-forths, it seemed that the street action, which was officially related to the course, did not really both-er Monsanto. Although no one responded to the questions, I gathered that a few bodies on the street in Chiapas can't be something to worry about. An Internet action, on the other hand, reaching a far broader audience (including the people who were considering granting permission to Monsanto), was no laughing matter.

So it went.

In October 2013, a local judge in Mexico City prohibited Sagarpa from granting Monsanto permission to plant GM corn in Mexico, either on an experimental, pilot, or commercial basis.[17] A recent ruling reiterated that position.[18] Subsequent court rulings have prohibited the planting of GM corn in Central America.

Did our digital action prove efficacious? Did we really derail Monsanto's plans? Although we would love to think so, and still wait for Monsanto to offer "proof" that we hurt them, this hoax was one of thousands of interventions that artists and activists constantly carry out to keep GMOs out of Mexico and other countries. But because "others" were doing something, did not mean that we shouldn't do anything. We were happy to be among people who use their talents to keep bad things from (further) happening.

But the action did place many in a "decision dilemma." Would NYU tell Monsanto to go away, and reiterate that NYU had nothing to do with the digital action (my suggestion)? Would the Hemispheric Institute have to distance itself even further from direct actions such as this one, stating that while members of Hemi might occupy Wall Street or protest against Monsanto, or participate in Denial of Service (DOS) attacks on the Mexican government's website, Hemi itself did none of these things?

As of this writing, the Hemi, NYU, Monsanto conundrum seems to have been resolved or, better, dropped. Monsanto, of course, is too smart to go after Yes Men. Monsanto "just" wanted a letter from NYU that declares our action unethical.

They were even willing for it be a confidential letter, read by only a few key people. No doubt this letter, had it been issued, would serve as additional fodder for Monsanto to show Mexican officials that the corporation had been wronged. But judge after judge in Mexico and Central America continued to rule against Monsanto and GMOs.

Happily, we were history.

But I too had been caught up in identity correction.

Have I changed tactics in regard to truth and power?

Yes ma'am!![19]

8

The FUTURE(S) of Performance

...

There have been many discussions and attempts to think
through the "future" of performance.

Is this nostalgia for an edgy 1960s past? Are those legendary
(and now older) artists turning their sights toward the preser-
vation of their work? Is performance art as a genre now passé?

The *New York Times* ran a front-page photo of an older couple
watching a video of performance art at the Whitney. The ar-
ticle was called "A Look Back at Performance Art."[1]

There are numerous reasons to consider the many lives of performance. And there are many impediments.

If performance exists solely in the second of its execution, how can it be "saved"? Documentation gives us a sense of what happened, but cannot capture the "live" performance itself. Performance archives, such as Hemi's HIDVL, preserve and make accessible hundreds of hours of videos of "live" and born digital performance, creating new digital artifacts to study and analyze for centuries to come. But they also raise new questions.[2] What will an audience make of the anticapitalist rants by faux evangelist Reverend Billy of the Church of Stop Shopping (U.S.) five hundred years from now?

8.1 Reverend Billy preaches at the Hemispheric Institute Encuentro, Buenos Aires, Argentina. 2007. Photo: Julio Pantoja

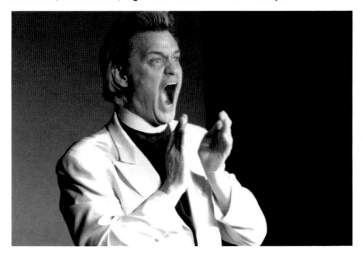

Looking at his material in the archive, Reverend Billy says he doesn't know if they are alive and he's dead, or whether they're dead and he's alive.

..

The archive, however, can also perform. We have seen many examples in which video and photographic documentation become part of a new performance. In its famous *Hamlet* (U.S., 2005), the Wooster Group performed a version of the classic text against the images of the Richard Burton performance of *Hamlet*, staged on Broadway in 1964 and filmed by seventeen cameras to be made into a film.[3] Instead of serving a documentary purpose, the film performed a haunting, channeling the ghost, Wooster Group said, of the legendary Burton performance.

Are we to understand this performing the archive as a *conservative* move, evidence that in order to be "new" and "groundbreaking" we need to turn to the past? Retro-mania?

The live and the archived, I believe, constantly interact in many forms of again-ness. Any given performance may be ephemeral, exceeding the archive's capacity to capture the "live." A photograph or video of a performance is not the performance. But this does not mean that the archive is "dead" or holds lifeless materials. The holdings in the archive—the videos that we see displayed, the photos, artifacts, and so on— can spring back to life. They convey a sense of what the performances meant in their specific context and moment, and what they might mean now.

Questions about whether "performance" disappears or remains fuel debates in the academy, the art world, and beyond. In 2003 Member States of UNESCO adopted the "Convention for the Safeguarding of the Intangible Cultural Heritage" based on the assumption that cultural practices were important, vulnerable, and in need of "safe-guarding." Future generations, some argue, will benefit from understanding those practices that, following the logic of the "world" heritage sites, belong to all of us. While I participated in the UNESCO process and contributed to the writing of the guidelines, I was aware of the complexities and contradictions of "saving" the live, of separating acts from their moment of knowing and being in the interest of safeguarding and performing them for other audiences at another moment. What, I wondered, was being "saved"? The form? The content? The meaning? And who are we saving it for?

In an earlier work I developed the idea of a "**repertoire**" of embodied acts—performances, gestures, orality, movement, dance, singing—acts usually thought of as ephemeral, non-reproducible knowledge. The repertoire, I said, requires presence—people participate in the production and reproduction of knowledge by "being there," being a part of the transmission. Yet the actions that are the repertoire do not remain the same. The repertoire both keeps and transforms choreographies of meaning.[4] I developed this idea in conversation with the more traditional "**archive**" of objects—books, documents,

bones, DVDs—that theoretically resist change over time. The archive has long been the guarantor of the preservation and accessibility of knowledge. Usually thought to be stable, the antithesis of the live, archives, and the objects in them, change over time. New objects come in, some magically vanish. The military dictatorship in Argentina eliminated the photographs of their "disappeared" victims from the national registries. No photo in the archive, no proof the person ever existed. The Mothers of Plaza de Mayo reactivated the photographs by wearing them, and bringing them back to life. They demanded that their children too be brought back to life. **The archive and the repertoire often work together, although each has its own logic and mechanisms of transmission.**

The archive is a slow performance.[5]

Both the archive and repertoire participate in the many lives and futures of performance.

In one sense, my idea of repertoire follows the logic of what some today call "reperformance." "Reperformance," we might say, underlines performance's reiterative nature as a specific strategy of renewal (artistic, pedagogical, managerial, political), always "twice behaved behavior," according to Richard Schechner, "never for the first time." But how does *reperformance* differ from *reenactment*, defined by Rebecca Schneider as "the practice of re-playing or re-doing a precedent event, artwork, or act"?[6]

The term "reperformance," like performance itself, has been taken up primarily in business, banking, and administration. Where it has referred to the arts, it has meant accurate replication of an original.[7] Perhaps the most famous example of reperformance took place during Marina Abramović's blockbuster show *The Artist Is Present* (MoMA, 2010). MoMA website's stated the intention of the reperformances: "to transmit the presence of the artist and make her historical performances accessible to a larger audience."[8] Notions of authenticity, originality, historicity, the accurate redo of great signature works, and broad accessibility underlie reperformance.

Let's look at two reperformances during the 2010 Abramović retrospective. The most obvious, yet least discussed *as* reperformance, was Abramović's live presence sitting at a table in the Marron Atrium of MoMA for the entire duration of the exhibition—over seven hundred hours.[9]

This was a reperformance of the 1980s *Night Sea Crossing* series that she undertook with her then collaborator and partner, Ulay (Uwe Layesiepen). Why does this get called a performance rather than a reperformance? Like that durational performance, in which the two sat still and silent facing each other across a table, this one is all about deep focus and seemingly superhuman physical and mental endurance. And like all performance, as Abramović put it, this one takes place in the "here and now."[10]

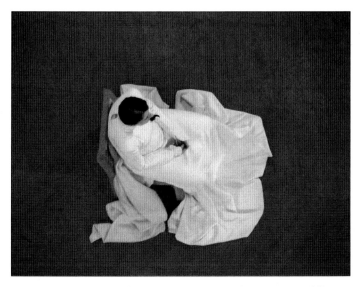

8.2 Marina Abramović in *The Artist Is Present*. Museum of Modern Art,
New York, 2010. Photo: Abigail Levine

The power of the performance lay in the stillness, the intensity
and public intimacy of the look, the interface not only between
two people, but two people and their multiple live and digi-
tal audiences. Nothing "happened." But even in its stillness,
the excruciating expenditure of doing nothing. Looking, for
Abramović as for the public, was the doing.

The cameras, video cams, and lighting made the very quiet and
still event intensely spectacular—it was all about being and
seeing.

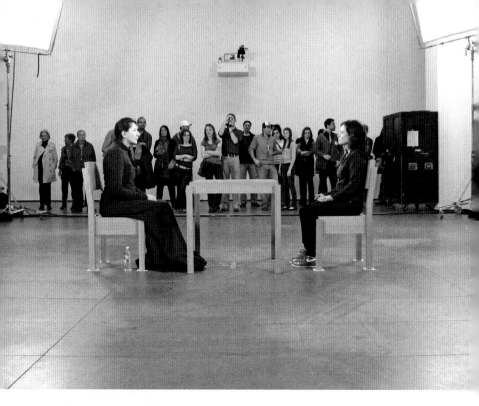

8.3 *Marina Abramović: The Artist Is Present*, Museum of Modern Art, New York, 2010. Photo: C-Monster

8.4 Screen shot of live video stream of *Marina Abramović: The Artist Is Present*

The artist was present here and now, and in many forms of again-ness: live, "live video," the preservation of the "live video," the photographs of the live video, and so on. All of these recordings, however, were part of the performance rather than merely its documentation or preservation.

All this, clearly, extended beyond the reiterative quality of the "re-" in "reperformance." This was a new "original," in the commercial art world's meaning of the word.

Upstairs, on the sixth floor of the museum, the illusion of liveness and presence was injected into (rather than emanated out of) every form of display—videos, projections, photos. We could see and hear her everywhere, dancing, screaming, talking. Along with all this, reperformances by artists Abramović trained, and hired by MoMA, performed several of Abramović's iconic works. These reperformances proved to be the most controversial and theoretically interesting part of the retrospective.[11] In the supposed realm of the repertoire, human bodies once again were harnessed to share and transmit experiences with other bodies.

But this is not the repertoire. Instead of animating and transmitting a live practice, the reperformance of Abramović's pieces at MoMA sharply worked against the piece's first iterations.

Here I will briefly note one example. In *Imponderabilia*, which Abramović performed with Ulay in 1977 in Bologna, the artists rebuilt the main opening to the museum to create a smaller

entryway through which the visitors had to pass. She and Ulay stood naked at the entrance, so narrow now that the visitor had to choose whether to face her or him while squeezing through. The idea activating the performance was that artists, not museums, are the guardians of art, and both artists and visitors had to negotiate the challenging and at times awkward relationship with them. While the performance was supposed to last six hours, the police arrived after three hours and asked the two for their papers that, clearly, they did not have on them. The performance stopped. Bologna in the 1970s was a political hot spot, and the police, who were not art patrons, had no sense of humor.

The reperformance in MoMA was radically different, even though it cited its iconic predecessor. Two artists (regardless of gender) took turns standing naked at a doorway in the large exhibition space that had videos and paraphernalia from several earlier pieces by Abramović. Unlike the Bologna staging, here the doorway was not only wider but it was a secondary door positioned at the far end of the room, rendering it redundant. Visitors did not have to go through it; they were not made uncomfortable. And artists, this suggested, were no longer guardians of anything special. They had been hired by MoMA to illustrate something else, the "original." The video of the Bologna performance played next to the reperformance— a reminder that this new iteration was interesting to the degree it conjured up the last. Performance, never for the first time and yet never the same twice, resists the notion of an "original"—a value added marker from the commercial art world. The artists were not recognized as performers—there

was no space from which to watch their performances or ways of evaluating them in their own right. The artist (singular) was present.

..

Additionally, the context was entirely different. The 2010 Abramović is a superstar, the retrospective was the mega commercial art event of the season, and no police were likely to interrupt the show. On the contrary—security guards stood closely by protecting the show and its actors. The actors, as employees of MoMA, were not allowed to put themselves at risk or perform for extended periods—thus annulling the exertion that underwrites Abramović's work. Instead of taking place outside the museum, challenging its role in the valorization and preservation of art, the performances of the retrospective turn to the museum precisely for valorization and preservation. Clearly the stakes of the performance and the context have changed profoundly since the 1970s. The "time past and time present unified together" that has fascinated Abramović since her first piece in 1973 shows two very different *nows* under the supposed continuity of specific performances.[12] That *now* marked (and obscured) the profound change of time rather than its durational qualities.

..

"Reperformance," as Abigail Levine notes, "must, essentially, become performance, an exchange in the present. If the reperformances become effective only in relation to the 'original' performance of the work, then they become a fragmentary form, another document."[13]

Reperformance, understood within the logic of cultural capital and economic circulation and preservation, is not, then, the future of performance, but rather its Mo-MAfication.[14]

A more promising strategy of keeping performance "alive" might be to reverse the process. Rather than reperform the archive, unleash it into the live with all its mediations, interpretations, and challenges.

During the retrospective, a group of unauthorized artists staged an alternate, one-day event, *The Artist Is Absent*. They reperformed some of Abramović's signature pieces on their own terms. They did not avoid the risk or expenditure of the earlier work. The statement they issued read:

> *Performance is a wild thing and a key part of performance art is, in fact, its unpredictability and its moment-to-moment honesty. We consider our re-performances successes regardless of whether or not the outcome is identical, provided that we have stayed within the formal structure delineated by the documentation of the work.*

[Re [performance]]

The "formal structure" or framework for quoting from earlier performances intrigues me. Paul Worley describes the ways in

which Mayan elders deliberately section out parts of their song with lines such as "Listen to what I'm going to tell you / This is the end of what I'm going to tell you / About what happens in the world."[15] The framing suggests the fantasy that this kernel of wisdom will be transmitted intact—straight from the ancients to those in attendance today. Rather than the "historical" or "authentic" label or the "truth value" attached to this framing, I value the strategy—as central to the Mesoamerican ancients as it is to the contemporary art market—of the self-conscious bracketing of one performance within another. The friction between the frames, rather than its elision, seems productive. It's all about the why do, for whom, and who decides.

9

Performance Studies

How would our disciplines and methodologies change if we took seriously the idea that bodies (and not only books and documents) produce, store, and transfer knowledge?

The move to reintroduce the body into the realm of scholarship has been as urgent and difficult as reintroducing the body into what counts as art and artistic practice. It is not a coincidence that the academic challenge of disciplinary limits began in the late 1960s, just as performance art was breaking institutional and cultural barriers.

The scholarly approaches have taken various forms. Performance studies developed out of departments of theatre, linguistics, communications, anthropology, sociology, and visual arts. And although it maintained ties to its genealogical sources, it refused to confine itself to the limits of these disciplines.[1] Performance studies, I believe, is ***postdisciplinary*** in the sense that it resists becoming a discipline with definable limits; it is (forever) an "emergent" field.

If the norm of performance is breaking norms, the norm of performance studies is to break disciplinary boundaries.

The epistemic turn prompted by embodied objects of analysis necessarily provoked shifts in what academic disciplines value as canonical texts, methodologies of study, objects of analysis, expertise, sources of knowledge, and systems of transmission. Performance studies departments have their own particular profiles, and their own ways of combining theoretical and practical work. When I joined performance studies at NYU as a faculty member in 1997, most of the departments were in English-speaking countries in the United States, the United Kingdom, and Australia. But as my work with the Hemispheric Institute developed, I came to understand that much performance studies scholarship, as Leda Martins of UFMG makes clear, is not limited to performance studies departments: "In Brazil, I would say we don't have departments, as you have, specifically dedicated to performance studies. We have schol-

ars and artists in departments in different fields who work with performance via either theatre departments or literature departments or anthropology."[2]

<hr/>

Scholars from around the world have different engagements and stakes in the questions they ask of the practices they examine. Here I quote from a series of thirty interviews with performance studies faculty in the Americas that I started in 2001, *What Is Performance Studies?*[3]

Barbara Kirshenblatt-Gimblett (New York University) speaks of performance as an "organizing idea."

Catherine Cole (University of California, Berkeley) says that "performance studies really explodes the frame, explodes the object of analysis in really interesting and exciting and productive ways, and confusing ways."

Antonio Prieto (University of Veracruz) understands "performance as a theoretical paradigm, including but not exclusive to action-based performance."

Tracy Davis (Northwestern) says she considers performance studies "not so much a discipline as a conversation."

Jesús Martín Barbero (School of Communications at Universidad del Valle, Colombia) regards performance studies as "a theoretical, methodological, and strategic space in which to think through the multiplicities of conflicts that traverse the body."

Joseph Roach (Yale University) turns to performance to understand not just the present but also the past: "The persistence of

the past has its consequences, and performance is the way in which you see it. . . . The history that comes through gesture, that comes through speech, that comes through song is all the more important to imagining history. . . . It can give you the affect as well as the cognitive grasp of the issues of the past."

Laura Levin (York University) defines performance as "a lens through which to read a range of different kinds of embodied cultural behaviors, including things like ritual, dance, popular entertainment, sporting events, and the enactment of self in everyday life. But in practice," she adds, "the more that I teach performance studies, I have started to think about it as a home for what I've been calling 'disciplinary misfits.' It is a place of refuge for scholars and artists for whom certain kinds of conversations have stalled in their own departments."

Zeca Ligiéro (Brazil) speaks of performance studies as "a territory without borders. . . . During its initial period, it established the bridge between the visual arts and performance. It has since expanded to almost all sectors of human life, from theatre to rituals and public celebrations to representations of daily life. From this perspective, it is now not only the visual artist or the actor who creates performance, but also the man on the street, the shop keeper, and the professor."[4]

What they have in common is their shared object of study: performance—in the broadest possible sense—as a process, a praxis, an episteme, a mode of transmission, an accomplishment, and a means of intervening in the world.

9.1 Photo: Alexei Taylor

What's interesting about performance studies, I believe, is not so much what it "is" but what it enables us to ***do***.

Studying "performance," we might argue, poses different challenges than studying a supposedly "fixed" text or a film. Even though we understand that texts change over time (different editions, folios, or translations can radically alter texts), and that the editing process can significantly reshape a film, the prevailing notion is that these cultural artifacts are stable and that performance is not. This book has made the case that performance changes constantly, depending on actors, context, and audience. A similar argument might be made that readers today in the United States are not the same as those in England during Shakespeare's time, for example, or that watching a film in the company of right-wing military officers might affect our experience of a politically progressive and sexually transgressive scene.

Nonetheless, performance is radically unstable, as I have noted throughout. I can ask students to turn to a certain passage in a text, or reexamine a moment in a film clip, but I can assume no shared reference or starting point with students or readers when I describe an escrache by H.I.J.O.S. or recall Jesusa and Liliana's wedding. How do we set the stage, study the "live," and communicate our theories in ways such that others can follow the argument and judge for themselves? How do scholars "frame" the object of analysis? How do they position the critical embodied "I" who is both part of the event, and yet frames it?

Performance studies scholars necessarily deal with these challenges in their own ways, evident in their own writings.

...

Many scholars, artists, activists, and artivists recognize that performance is a privileged form through which to intervene in the world. Throughout the book, we have seen how governments control bodies, capitalism commodifies them, big pharma pacifies them, and institutions at times try to accommodate them. The political and social efficacy of the embodied practices extends well beyond them all.

Persuasive, performatic, and symbolic, embodied practices can be used to solidify, analyze, or challenge structures of power.

...

Since the times of Plato, if not before, scholars, artists, and activists have been relegated to different realms of doing. Although they might focus on the same issues or participate in the same struggles, rarely do they work together to collaborate in their efforts. There has been ample suspicion on all sides, caused in part by the same disciplinary boundaries that I mentioned earlier. The stereotype has been that academics think and talk, artists create, and activists take action. The terminology that scholars use to articulate their ideas remains, in many cases, foreign to those outside of academia. The circle of interlocutors becomes smaller. Academics are also criticized for shutting themselves up within their institutions and separating themselves from the concrete conflicts fought out in the world. They enjoy the support of the university, the critique

goes, while artists starve and activists risk their lives in the streets. The suspicions are many, the modes of expression divergent, and the spheres of action usually separated from one another.

In 1998, a group of *acadevists* (activist-academics) founded the Hemispheric Institute of Performance and Politics to spark dialogue and bring scholars, artists, and activists together throughout the Americas. About 120 people from some twenty countries huddled together in Rio de Janeiro in 2000 to dissect the problems. The list went on and on. The funding came from U.S. foundations. Surely this was a capitalist, imperialist venture. We didn't all speak or understand the same languages—why isn't everything translated? Why was it necessary to include academics, asked the artivists? Those who act, those who intervene with their bodies, have nothing to do with them. And of course, the inevitable, what is *performance* anyway?

Fifteen years later, the conversations continue, though they have become less heated around these particular issues. As many participants throughout the Americas feel invested in maintaining this multisite (digital, embodied, archival) of interaction, the funding has become more diversified. And no, we do not all understand each other—we never will. That is the necessary condition of working outside our very restricted fields. The challenge proves productive for all of us as we try to communicate across many divides (linguistic, geographical, disciplinary, economic, to name a few). And, we academics re-

plied to the artivists: Embodied practice has nothing to do with us? We began to talk about the complications of the notion of "the body." The body is not something monolithic and static. The ways in which concepts such as gender, sexuality, race, age, and social class, for example, have constructed human bodies is something that artists and activists now take for granted, but this idea was not obvious before academics suggested it. Soon, we began to realize that all of us who work on and with performance had something to add to the collaboration. We came together around many goals and conflicts. The struggles have been fought on several fronts simultaneously: concrete spaces such as Zuccotti Square and Mexico City's Zócalo. But they also take place in more diffuse spaces, such as the idea of the nation-state for the Zapatistas, and the online activism of the Yes Men.

In postdisciplinary fields such as performance studies, and in networks such as the Hemispheric Institute of Performance and Politics, we continue debating whether performance is a political act by definition, and/or if the political is always a performance. We each have a different relationship to performance, though we are all involved in its production and its reception, itself a form of intervention. As Boal made clear, theatre (I would say performance) is a very powerful weapon, and for that reason, we must fight for it. Its force depends on who wields it and why. As a lens, performance also allows us to recognize acts in the past. We understand certain routes of migration in the Americas by tracing the music or the dancing or the fiestas that made their way through the territory. As a

practice, performance constitutes a means of communication, a doing, and a doing *with* and *to*. As an act of imagination, performance allows us to imagine better scenarios and futurities. José Esteban Muñoz put it eloquently: "Some will say that all we have are the pleasures of this moment, but we must never settle for that minimal transport; we must dream and enact new and better pleasures, other ways of being in the world, and ultimately new worlds."[5]

Performance is world-making. We need to understand it.

Notes

...

Chapter 1

1. Hemispheric Institute "Senior Fellow" acceptance speech, Bogotá, Colombia, 2009.

2. Guillermo Gómez-Peña in "The Mexorcist 2," *Archives*, 2006.

3. The discussion around the word "performance" and its purchase in Latin America comprises chapters 2 and 3 of the Spanish-language version of this book.

4. Elin Diamond, ed., *Performance and Cultural Politics* (New York: Routledge, 1996), 5.

5. Mark H. C. Bessire, *William Pope.L: The Friendliest Black Artist in America* (Cambridge, MA: MIT Press, 2002), 23.

6. Peggy Phelan, *Unmarked: The Politics of Performance* (London: Routledge, 1993), 146.

7. Vittorio Gallese, "The 'Shared Manifold' Hypothesis: From Mirror Neurons to Empathy," *Journal of Consciousness Studies* 8, nos. 5–7 (2001): 33–50, www.imprint-academic.com/jcs.

8. Anna Deavere Smith, "The World Becomes You." An interview with Carol Martin, *TDR* 37, no. 4 (Winter 1993): 51.

9. Maris Bustamante, "Picardía Femenina," http://revista.escaner.cl/node/383 (accessed September 18, 2015, my translation).

10. Augusto Boal, *Theatre of the Oppressed* (New York: Theatre Communications Group, 1985), 143–44.

11. Tehching Hsieh: One Year Performance 1980–1981, https://www.youtube.com/watch?v=tvebnkjwTeU (accessed March 29, 2015).

12. See Patrick Anderson's *So Much Wasted: Hunger, Performance, and the Morbidity of Resistance* (Durham: Duke University Press, 2010).

13. Richard Schechner, *Between Theatre and Anthropology* (Philadelphia: University of Pennsylvania Press, 1985), 36.

14. Richard Schechner, *Performance Studies: An Introduction*, 2nd ed. (London: Routledge, 2006), 38.

15. Judith Butler, *Gender Trouble* (New York: Routledge, 1990).

16. Julieta Paredes, *Hilando fino desde el femenismo comunitario*, performance and presentation at New York University, April 5, 2010.

17. Victor Turner, cited in Richard Schechner and Willa Appel, *By Means of Performance: Intercultural Studies of Theatre and Ritual* (Philadelphia: University of Pennsylvania Press, 1990), 1. Part of this argument is restaged from *The Archive and the Repertoire* (Durham: Duke University Press, 2003), ch. 1.

18. Fray Bernardino de Sahagún, *Historia general de las cosas de Nueva España*, prologue to book 1 (Mexico City: Porrúa, 1985).

Chapter 2

1. Carolee Schneeman, *Carolee Schneeman: Imaging Her Erotics* (Cambridge, MA: MIT Press, 2002), 28.

2. Marvin Carlson, *Performance* (New York: Routledge, 1996), 105.

3. Rebecca Schneider, "Solo, Solo, Solo," in *After Criticism: New Essays in Art and Performance*, ed. Gavin Butt (London: Blackwell, 2005).

4. Francisco Copello, *Fotografía de performance: Análisis autobiográfico de mis performances* (Santiago de Chile: Ocho libros editores, no date).

5. Kathy O'Dell, "Contact with the Skin: Masochism," in *Performance Art and the 1970s* (Minneapolis: University of Minnesota Press, 1998), 2.

6. Julie Tolentino Wood, "Queer Pleasures," introduction by Debra Levine, *E-misférica* 4.1 Affect, Performance & Politics, http://hemi.nyu.edu/journal/4_1/artist_presentation/jt_eng/images.html (accessed March 29, 2015).

7. Diamela Eltit, private conversation with the author, New York, fall 2013.

Chapter 3

1. Plato, *The Republic*, introduction and translation by H. D. P. Lee, 374–75 (Baltimore: Penguin Classics, 1955).

2. Diana Taylor, *Disappearing Acts: Spectacles of Gender and Nationalism in Argentina's "Dirty War"* (Durham, NC: Duke University Press, 1997), chap. 5.

3. Samuel Coleridge Taylor, *Biographical Sketches of My Literary Life and Opinions* (Princeton, NJ: Princeton University Press, 1985).

4. Antonin Artaud, *The Theatre and Its Double*, trans. Mary Caroline Richards (New York: Grove, 1958), 27.

5. Louis Althusser, *For Marx*, trans. Ben Brewster (Harmondsworth, UK: Penguin Books, 1969), 148–49.

6. Loren Kruger, in *Post-Imperial Brecht*, points out the correct translation of *Verfremdung* (Cambridge: Cambridge University Press, 2004), 20.

7. Bertolt Brecht, "A Short Organum for the Theatre," in *Brecht on Theatre*, ed. and trans. John Willett (New York: Hill and Wang, 1964), sections 21, 26, and 40.

8. Artaud, *The Theatre and Its Double*, 13.

9. Jacques Rancière, *The Emancipated Spectator*, trans. Gregory Elliott (London: Verso, 2010), 13.

10. Vittorio Gallese, "The 'Shared Manifold' Hypothesis: From Mirror Neurons to Empathy," *Journal of Consciousness Studies* 8, nos. 5–7 (2001): 37, http://didattica.uniroma2.it/assets/uploads/corsi/33846/Gallese_2001.pdf.

11. Arielle Azoulay, *The Civil Contract of Photography* (New York: Zone Books, 2008), 130–33.

12. Georges Didi-Huberman, *Images in Spite of All*, trans. Shane B. Lillis (Chicago: University of Chicago Press, 2008), 3.

Chapter 4

1. Jon McKenzie, *Perform or Else: From Discipline to Performance* (London: Routledge, 2001), 3.

2. McKenzie, *Perform or Else*, 83.

3. Rossana Reguillo, "Sujetividad sitiada: Hacia una antropología de las

pasiones contemporáneas" ("Passions, Performance, and Public Affects"),
E-misférica 4, no. 1, http://hemisphericinstitute.org/hemi/en/e-misferica
-41/reguillo (accessed April 6, 2013).

4. Sigmund Freud, "Thoughts for the Times on War and Death" (1915), in *The Standard Edition of the Complete Psychological Works of Sigmund Freud*, vol. 14 (1914–16): *On the History of the Psycho-Analytic Movement, Papers on Metapsychology and Other Works*, trans. and ed. James Strachey (London: Hogarth, 1957), 288.

5. Jon Stewart, *The Daily Show*, September 16, 2010, http://www.thedailyshow
.com/watch/thu-september-16-2010/rally-to-restore-sanity.

6. Roger Cohen, "Premiumize or Perish," *New York Times*, September 14, 2008.

7. Cohen, "Premiumize or Perish."

8. Gilles Deleuze and Félix Guattari, *Anti-Oedipus: Capitalism and Schizophrenia*, trans. Robert Hurley, Seem Mark, and Helen R. Lane (Minneapolis: University of Minnesota Press, 1983).

9. Guy Debord, *Comments on the Society of the Spectacle*, trans. Malcolm Imrie (New York: Verso, 1998).

10. Debord, *Comments on the Society of the Spectacle*, 24.

11. Audi commercial, "Designed to Thrill," 2011, http://www.ibelieveinadv
.com/commons/audi2.jpg.

12. Critical Art Ensemble, "Recombinant Theatre and the Performative Matrix," in *The Electronic Disturbance*, http://critical-art.net/books.html (accessed March 30, 2015).

13. Paul Beatriz Preciado, *Testo Junkie: Sex, Drugs, and Biopolitics in the Pharmacopornographic Era*, trans. Bruce Benderson (New York: Feminist Press, 2013).

14. Personal communication with Diana Taylor, August 2010.

15. Debord, *Comments on the Society of the Spectacle*, 24.

16. For a longer analysis, see my essay "War Play," in "War," ed. Diana Taylor and Srinivas Aravamudan, special issue, *PMLA* 124, no. 5 (October 2009): 1886–1895.

Chapter 5

1. J. L. Austin, *How to Do Things with Words*, 2nd ed. (Cambridge, MA: Harvard University Press, 1975), 8, italics in the original.

2. Jorge Portilla, *Phenomenology of Relajo* (Mexico City: Fondo de Cultura Económica, 1986).

3. Peter Kilchmann and Francis Alÿs, "Cuentos Patrióticos or The Multiplication of Sheep, 1979," http://www.peterkilchmann.com/artists/overview/++/name/francis-al%25C3%25BFs/id/52/media/al__s11573.jpg/ (accessed April 14, 2015).

4. I write about this elsewhere: "Remapping Genre through Performance: From American to Hemispheric Studies," in "Re-mapping Disciplines," special issue, ed. Wai Chee Dimock and Bruce Robbins, PMLA 122, no. 5 (October 2007): 1416–30.

5. Jacques Derrida, "Signature, Event, Context," in *Margins of Philosophy*, trans. Alan Bass (Chicago: University of Chicago Press, 1984), 326.

6. Judith Butler, *Bodies That Matter* (London: Routledge, 1993), xii.

7. Judith Butler, "Rethinking Vulnerability and Resistance," lecture, Madrid, June 2014, p. 7. http://www.institutofranklin.net/sites/default/files/files/Rethinking%20Vulnerability%20and%20Resistance%20Judith%20Butler.pdf (accessed September 3, 2015).

8. Peggy Shaw, *A Menopausal Gentleman*, ed. Jill Dolan (Ann Arbor: University of Michigan Press, 2011), 76.

9. Manuel Castells, *Networks of Outrage and Hope: Social Movements in the Internet Age* (Cambridge: Polity, 2012), 134.

10. Memoria Chilena notes: "El escándalo era la constante de las 'Yeguas.'" http://www.memoriachilena.cl/602/w3-article-96708.html (accessed April 14, 2015).

11. Slavoj Žižek, "Shoplifters of the World Unite," *London Review of Books*, August 19, 2011, http://www.lrb.co.uk/2011/08/19/slavoj-zizek/shoplifters-of-the-world-unite (accessed April 14, 2015).

12. Slavoj Žižek, "Trouble in Paradise," *London Review of Books*, July 18, 2013, 11–12, http://www.lrb.co.uk/v35/n14/slavoj-zizek/trouble-in-paradise (accessed April 14, 2015).

13. Sianne Ngai, *Ugly Feelings* (Cambridge, MA: Harvard University Press, 2005), 91, 123.

14. Jack Halberstam, "Going Gaga: Chaos, Anarchy and the Wild," ICI Berlin, February 6, 2013, https://www.ici-berlin.org/videos/halberstam (accessed April 14, 2015).

Chapter 6

1. McKenzie, *Perform or Else*, 18; italics in the original.

2. McKenzie, *Perform or Else*, 12.

3. Aristotle, *Poetics*, trans. Gerald F. Else (Ann Arbor: University of Michigan Press, 1973), section 6, p. 20.

4. S.v. "scenario," in *Wikipedia*, http://en.wikipedia.org/wiki/Scenario (accessed January 17, 2014).

5. Tamara L. Underiner, "Playing at Border Crossing," TDR—*The Drama Review* 55, no. 2 (2011): 11–32.

6. Ioan Grillo / Parque Alberto, "In Mexico, a Theme Park for Border Crossers," *Time*, November 11, 2008, http://www.time.com/time/world/article/0,8599,1858151,00.html.

7. Richard V. Ericson and Kevin D. Haggerty, *The New Politics of Surveillance and Visibility* (Toronto: University of Toronto Press, 2006), 4.

8. Jacques Lacan, "The Mirror Stage as Formative of the Function of the I," in *Écrits*, trans. Alan Sheridan (New York: Norton, 1977), 1–7.

9. See my longer discussion of scenarios in "Scenarios of Discovery: Reflections on Performance and Ethnography," in *The Archive and the Repertoire* (Durham, NC: Duke University Press, 2003), chap. 2.

10. Stephen Colbert, *The Colbert Report*, Comedy Central, June 28, 2010, http://thecolbertreport.cc.com/videos/nxs1np/doomsday-bunkers.

11. My essay "War Play" uses some of this same language to examine the U.S. military simulations in the Mojave Desert. In that case, I conclude, the simulations in the California "sandbox" create the very real outcomes in Iraq, also known as the "sandbox."

12. See www.msr.org.il. I am grateful to MSR's director, Dr. Amitai Ziv, and its

deputy director, Kim MacMillan, for the access they allowed me to observe their simulations and visit their facilities in May 2009 and May 2010.

13. Thanks to Kim Macmillan, deputy director of MSR, for this information (via personal correspondence). The results of a study of the stress-related effects in simulation were compiled by Atalia Tuval, Avner Sidi, Amitai Ziv, Dalia Etzion, Tiberio Ezri, and Haim Berkenstadt, and are available through MSR as "Psychological and Physiological Stress Reactions of Anesthesiology Residents during Simulation Based Board Exams."

14. MSR spells out the five aspects of scenario training: "Safe environment—mistake forgiving; Proactive and controlled training; Trainee/Team/System centered education; Feedback and debriefing based education; Reproducible, standardized, objective." Brochure, "For a safe, humane, ethical and patient-centered medical culture."

15. See *The Archive and the Repertoire: Performing Cultural Memory in the Americas* (Durham: Duke University Press, 2003); Marianne Hirsch, "Editor's Column: What's Wrong with These Terms? A Conversation with Barbara Kirshenblatt-Gimblett and Diana Taylor," *PMLA* 120, no. 5 (October 2005): 1497–1508; and Hirsch, "War Play," in "War," ed. Srinivas Aravamudan and Diana Taylor, special issue, *PMLA* 124, no. 5 (October 2009).

16. Sherry Turkle, *Simulation and Its Discontents* (Cambridge, MA: MIT Press, 2009), 9.

17. Turkle, *Simulation and Its Discontents*, 13.

18. Turkle, *Simulation and Its Discontents*, 45.

Chapter 7

1. Regina José Galindo, personal communication, January 14, 2014.

2. "I feel impotent, I cannot change the way things are. But this rage sustains me, and I have watched it grow since I became aware of what was going on. It's like a motor, a conflict inside me that never yields, never stops spinning, never." "Regina José Galindo," interview by Francisco Goldman, *BOMB* 94 (Winter 2006), http://bombmagazine.org/article/2780/ (accessed April 14, 2015).

3. http://hemisphericinstitute.org/hemi/en/galindo-intro (accessed January 14, 2014).

4. Nadia Seremetakis, ed., *The Senses Still: Perception and Memory as Material Culture in Modernity* (Chicago: University of Chicago Press, 1994), 12. Quoted in André Lepecki, *Exhausting Dance: Performance and the Politics of Movement* (London: Routledge, 2006), 15.

5. GGP, 2005 interview with Jennifer González.

6. Galindo is Guatemala's best-known performance artist. She was awarded the Golden Lion award at the Venice Biennale in 2005. She has performed extensively internationally, including a solo show at Exit Art in 2009. In 2011 she received Grand Prize at the Biennial of Graphic Arts in Ljubljana.

7. "Regina Jose Galindo."

8. Fulana: *Amnezac,* http://hidvl.nyu.edu/video/000516509.html.

9. "Lit. 'private person,' used patronizingly for 'ignorant person, from idios 'one's own,'" http://www.etymonline.com/index.php?allowed_in_frame=0&search=private+person&searchmode=none (accessed January 14, 2014).

10. Bill Brown, ed., *Things* (Chicago: University of Chicago Press, 2005), 10.

11. The Yes Men, http://theyesmen.org/ (accessed April 14, 2015).

12. The Yes Men, The Bhopal Disaster, December 2004, http://www.youtube.com/watch?v=LiWlvBro9eI for the fake Dow Chemical announcement on the BBC and http://www.democracynow.org/2009/10/20/yes_men_pull_off_prank_claiming for the Chamber of Commerce hoax.

13. Personal communication with Jacques Servin, September 2014.

14. Beautiful Trouble, http://explore.beautifultrouble.org/#o:identity-correction (accessed April 14, 2015).

15. "Convention on Biological Diversity (CBD) adopted in 1992, the 190 ratifying countries agreed on the importance of establishing adequate safety measures for the environment and human health to address the possible risks posed by GMOs (genetically modified organisms). Intense negotiations started in 1995 and resulted in the adoption of the final text of the Cartagena Protocol on Biosafety (thereafter referred to as the Biosafety Protocol or BSP) in 2000." http://www.google.com.mx/url?sa=t&rct=j&q=&esrc=s&source=web&cd=1&ved=0CCYQFjAA&url=http%3A%2F%2Fwww.greenpeace.org%2Finternational%2FPageFiles%2F24242%2FGeneralbackgrounderMOP.doc&ei=jjThUtniKvfLsASF-4CIDQ&usg=AFQjCNHlDqZE_Lqbhy9j1sGF6ZQX1Rzbgg&sig2=Cr_S16Zs8FE3TqQoTtPZ7A&bvm=bv.59568121,d.cWc (accessed January 15, 2014).

16. For the full announcement, see http://monsantoglobal.com.yeslab.org
/mexico-grants-mexico-approval-to.html. For the fake website, go to http:
//monsantoglobal.com.yeslab.org/mexico-grants-mexico-approval-to.html
(accessed April 14, 2015).

17. See http://www.nationofchange.org/mexico-bans-gmo-corn-effective
-immediately-1382022349 and http://www.sinembargo.mx/10 (accessed
April 14, 2015). For more information about the situation in Mexico in
regard to Monsanto, and the activists who are working to keep the transna-
tional corporation out, see http://www.semillasdevida.org.mx/index
.php/component/content/article/91-categ-analisis-de-coyuntura-2013/145
(accessed April 14, 2015).

18. Angélica Enciso. "Firme, la suspensión de permisos para cultivo de maíz
transgénico." http://www.jornada.unam.mx/2013/12/24/politica/020n1pol
(accessed April 14, 2015).

19. Thanks to Mary Notari, the original YES MA'AM, and Jacques Servin, for
conferring this title on me.

Chapter 8

1. "A Look Back at Performance Art," *New York Times*, November 1, 2013.

2. HIDVL, The Hemispheric Institute Digital Video Library, http://
hemisphericinstitute.org/hemi/en/hidvl.

3. See the Wooster Group's website: http://thewoostergroup.org/twg/twg
.php?hamlet (accessed January 25, 2014).

4. Taylor, *The Archive and the Repertoire: Performing Cultural Memory in the
Americas* (Durham: Duke University Press, 2003).

5. Here I am riffing off something my colleague Barbara Kirshenblatt-Gim-
blett says: "A thing is a slow event." She said that the existential philoso-
pher Stanley Eveling first said this, and she heard it from Eveling's student
Katharine Young.

6. Rebecca Schneider, *Performing Remains: Art and War in Times of Theatrical
Reenactment* (London: Routledge, 2011), 2.

7. See for example Zenph Studios' reperformance of Glenn Gould's perfor-
mance of Bach's Goldberg Variations in 2006, cited in Nick Seaver, "A Brief
History of Re-Performance" (MA thesis, MIT, 2010), http://cms.mit.edu
/research/theses/NickSeaver2010.pdf.

8. *Marina Abramović: The Artist Is Present*, http://www.moma.org/visit/calendar/exhibitions/965 (accessed December 6, 2010).

9. Thanks to Abigail Levine, one of the reperformers in the Abramović retrospective, for talking through many of the details of the performances with me.

10. Abramović, MoMA Multimedia, "Marina Abramović. Nightsea Crossing," http://www.moma.org/explore/multimedia/audios/190/1985 (accessed April 14, 2015).

11. Carrie Lambert-Beatty, in "Against Performance Art" (*Artforum International* 48 [May 2010]) writes: "More interesting than whether reenactments are art-historically correct is what they are asked to do—whether they close down or open up the potentiality of performance" (209).

12. Lambert-Beatty, "Against Performance Art."

13. Abigail Levine, "Marina Abramović's Time: The Artist Is Present at the Museum of Modern Art," in "After Truth," *E-misférica* 7, no. 2, http://hemisphericinstitute.org/hemi/en/e-misferica-72/levine.

14. Thanks to Marlène Ramírez-Cancio for this gift.

15. Paul Worley, "'Well, I'll tell you what happened . . .': Oral Storytelling as a Yucatec Maya Strategy of Resistance," in *Resistant Strategies*, ed. Marcos Steuernagel, digital book, in progress.

Chapter 9

1. Shannon Jackson, *Professing Performance* (Cambridge: Cambridge University Press, 2004).

2. Diana Taylor and Marcos Steuernagel, eds., *What Is Performance Studies?* (Durham: Duke University Press, forthcoming), digital book.

3. Taylor and Steuernagel, *What Is Performance Studies?*

4. Zeca Legiéro, "Cultural Perspectives of Performance Studies," in "Opercevejo," special edition, *Revista de teatro* (Universidade Federal do Estado do Rio de Janeiro) 11, no. 12 (2003): 3.

5. José Esteban Muñoz, *Cruising Utopia: The Then and There of Queer Futurity* (New York: New York University Press, 2009).

Index